THE UNIVERSAL PENMAN

Engraved by

GEORGE BICKHAM

LONDON 1743

With an introductory essay by

PHILIP HOFER

CURATOR, DEPARTMENT OF PRINTING AND GRAPHIC ARTS,
HARVARD COLLEGE LIBRARY

DOVER PUBLICATIONS, INC., NEW YORK

This Dover edition, first published in 1954, is an unabridged
and unaltered republication of the 212 plates comprising *The
Universal Penman* as published by George Bickham, London,
circa 1740–1741. All plates are reproduced original size.
This edition also contains an introductory essay by Philip Hofer
reprinted with permission from *The Universal Penman* (facsimile
reprint), published by Paul A. Struck, New York, in 1941.

International Standard Book Number: 0-486-20616-5
Library of Congress Catalog Card Number: 54-13017

Manufactured in the United States of America

Dover Publications, Inc.
180 Varick Street
New York, N.Y. 10014

THE IMPORTANCE OF "THE UNIVERSAL PENMAN" IN RELATION TO MODERN CALLIGRAPHY

LATE in the seventeenth century English calligraphy became important and influential on the course of writing styles for the first time. To be sure, Alcuin of York helped to establish the Caroline minuscule as a nearly universal script in the early ninth century. But the minuscule was not an English hand. William Caxton, who introduced printing into England in 1476-7, used a local, rather crabbed hand (sometimes said to be his own) on which to base his over-admired type. Esther Inglis, most gifted of sixteenth century calligraphers working in England, was really a French woman. So we come, without reason for pause, to the galaxy of English writing masters of the late seventeenth century: men like Cocker, Ayres, More, Smith, Seddon, and Snell, who inspired an even larger group of professional scribes in the first quarter of the eighteenth century. From 1680 to 1740 hardly a year passed without an important copy book appearing. And all of this activity and interest was caused by just two things: the rising importance of English commercial enterprise, and the development, under these writing masters, of a round, even, flowing hand for business correspondence, which proved to be a well-nigh perfect technique when used by well trained clerks. It was legible, neat in appearance, and, above all, swifter in execution than any of the hands practised at that time elsewhere in Europe. Thus one is not surprised to find that even such practical men of affairs as Samuel Pepys became interested in good writing, and collected copy books and specimens of the period.

In 1733 an enterprising engraver and calligrapher, George Bickham, decided it was time to make a compendium of contemporary English work. The importance of the English writing masters was then patent to everyone. And yet, without considerable means and great trouble, a representative collection of their different hands as adapted to various purposes could not be gathered together. Therefore, he began his monumental work, "The Universal Penman", which is the subject of this present, much needed facsimile. This he issued to subscribers in a series of parts. Fifty-two of them appeared altogether—not one a week, as was the practise in later, more efficient times, but over a period of eight years. The astonishing fact is that this work today remains the only reasonably complete representation of English writing styles of a given period!

After the parts of "The Universal Penman" had been sent to subscribers, those who desired to keep them permanently customarily had them bound up. Naturally, since they were for use more than for aesthetic enjoyment, many parts had been lost. Moreover, Bickham himself seems to have made a considerable number of substitutions. The result is that whether so-called "complete" copies were bound up from the plates which the subscribers brought in, or were made up at Bickham's place of business, or in his house, they varied widely as to the number, the order, and even the identity of the plates. Ambrose Heal, the leading bibliographer of English writing masters, specifies that 212 plates, numbered consecutively, are comprised in a perfect copy. We may, therefore, take this figure as the standard of perfection, but must realize that only a few copies will meet it, and that even these will undoubtedly contain certain variations in bibliographical details. The present facsimile is that of an ideally perfect copy.

Bickham was not thinking about such minutiae during the eight years of his work. He was a professional engraver, who turned his hand to all the types of work that came to him. Twenty-five penmen would *appear* to have contributed specimens for him to engrave. Among these were the best masters of the day: Austin, Bland, Brooks (both William and Gabriel), Chambers, Champion, Clark, Morris, and Vaux. But also amongst them we find three men of his own name, with varying initials, whom we may suspect to have perhaps been sometimes identical with himself. We know that his son(?), George Bickham, Jr., was only a professional engraver and not a writing master. Nor does George Bickham (Senior) remember to sign or date all of his plates. His address varies frequently. Thus we suppose that, like most artists, George Bickham was simply habitually careless!

The "Universal Penman" is a rare book today in anything like complete state and in good condition. It is folio size, easily broken with usage. It is of a kind which collectors have not happened to take up in their somewhat haphazard search for beauty and curiosity. So copies were either worn out by hard usage, torn up by the thoughtless, or left to be ruined by dampness and by neglect. This process was furthered by the fact that the art of writing, about one hundred years ago, began to fall into very low estate. When the typewriter came, it submerged what little calligraphic interest remained; for even account books and legal documents could then be more legibly typed than written by long hand. Naturally this same development has had a wide effect on handwriting in general. One cannot say that the average man's hand today is properly legible. It is too hurried, too undisciplined. It is certainly completely without consideration for beauty and grace.

But in spite of current bad habits, and apparent public

apathy, there is an awakening perceptible. Many professional artists and some intelligent critics and teachers are already aware of it. This movement may have had its origin in the Morris revival, but it can be more clearly traced to the lectures of Edward Johnson and Graily Hewitt in England and Germany, about 1905-6. In this country it can be credited to William A. Dwiggins as much as to anyone. For decades now he has very subtly, and convincingly, proved by his designs, first for commercial advertising, and later for magazine covers, book jackets and title pages, the effectiveness and decorative quality of good lettering. Following his lead, other artists have begun to redesign every sort of label, sign, advertisement and poster—not perfectly, of course, but with increasing respect for traditional writing hands, particularly the greatest school of all, the Italian humanistic school of the sixteenth century. One has only to look back at placards of the late nineteenth century to see what enormous strides have already been made. But one should also look at American paper currency and postage stamps to see what remains to be done still.

Today, photo-mechanical reproductive processes give us an opportunity, without precedent since the Middle Ages, to develop fine writing hands for effective use, as well as for their beauty. As printers and publishers are alike beginning to realize, they furnish an increasingly easy means of printing texts as well as titles without having to set up, or to use, type. One can simply reproduce the author's (or designer's) writing hand. This offers much greater latitude in the arrangement of pages, and particularly in fitting diagrams or illustrations in with text. Indeed, one has all the freedom that the scribe and illuminator had at the end of the Middle Ages! Books may be just as gay with color and as harmonious in style. Finally, it has been definitely proved that the human eye reacts more favorably to the slight uneveness

of writing than to mechanically perfect type. The adjustment to reading a cursive hand as easily as formal letters is a very slight one. There may even prove to be less fatigue to the eye.

Altogether, there are many reasons why every intelligent person should take a renewed interest in good handwriting. The range is infinitely greater than in types, and much more individuality is possible. The publisher of this facsimile of "The Universal Penman", therefore, deserves to be thanked and congratulated. For he has made readily available a book which the student and the professional letterer *must* possess. As for the intelligent amateur, he may well find in it seed for thought and emulation, as well as sincere aesthetic pleasure.

<div align="right">Philip Hofer</div>

1 January 1941

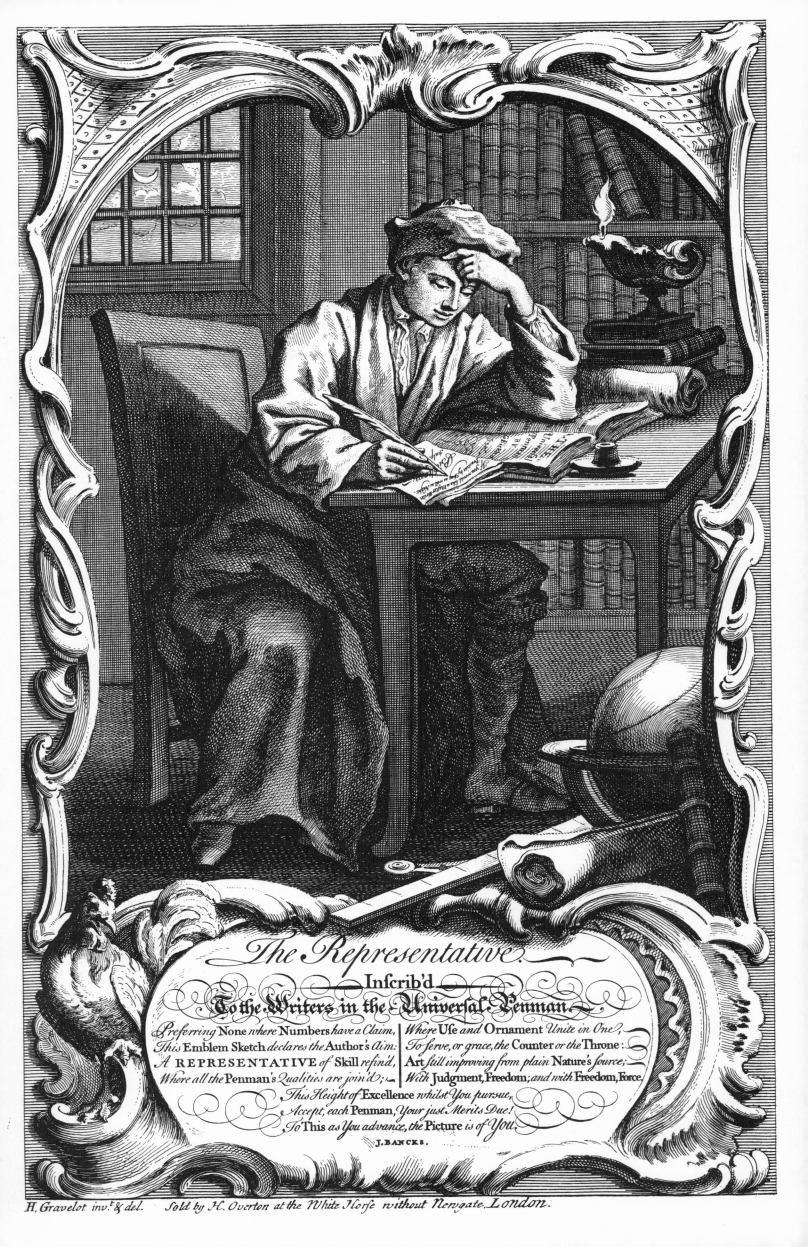

The Representative.

Inscrib'd

To the Writers in the Universal Penman.

Preferring None where Numbers have a Claim,
This Emblem Sketch declares the Author's Aim:
A REPRESENTATIVE of Skill refin'd,
Where all the Penman's Qualities are join'd;
This Height of Excellence whilst You pursue,
Accept, each Penman, Your just Merits Due!
To This as You advance, the Picture is of You.

Where Use and Ornament Unite in One,
To serve, or grace, the Counter or the Throne:
Art still improving from plain Nature's source;
With Judgment, Freedom; and with Freedom, Force.

J. BANCKS.

H. Gravelot inv.t & del. Sold by H. Overton at the White Horse without Newgate, London.

THE
Universal Penman.

Engrav'd
By GEORGE BICKHAM.

DELECTANDO · MONEMUS

London.

Printed for the Author, and Sent to the Subscribers, if
Living within the Bills of Mortality.

THE

Universal Penman;

Or, the

Art of Writing

Made Useful

To the Gentleman and Scholar, as well

As the Man of Business.

Exemplified

In all the useful, and ornamental Branches of Modern Penmanship; with

some necessary Observations on the Excellency of the Pen, and a large Number

of select Sentences in Prose and Verse; various Forms of Business, relating to

Merchandize and Trade; Letters on several Occasions; accurate Specimens

of the Oriental Languages, and Alphabets in all the Hands now practis'd.

Written,

With the friendly Assistance of several of the most Eminent Masters,

And Engrav'd, by Geo. Bickham.

The Whole Embelish'd with beautiful Decorations for the Amusement of the Curious.

LONDON:

Printed for, and Sold by the Author, at the Crown in James Street, Bunhill Fields, 1741.

To the
KING,
And to the
Nobility, and Gentry of
GREAT-BRITAIN;
This Book,
Intitled the Universal Penman,
Is most humbly Dedicated; by
His Majesty's most loyal Subject;
And Their Obedient, and
most devoted humble Servant,
George Bickham

Oh, Monarch of Britannia! Condescend
Ingenious Arts to succour, and befriend:
Nor ye Nobility! Or Gentry! slight
These curious Works of profit, and delight:
Protect this Book, 'twill raise a lasting Name,
And crown your Goodness with immortal Fame!

May all our Noble Youth some Profit find,
By these Amusements, to improve their Mind!

May ev'ry Line, in each resplendent Page,
Instruct, and Entertain their growing Age!

G. Bickham Scic.

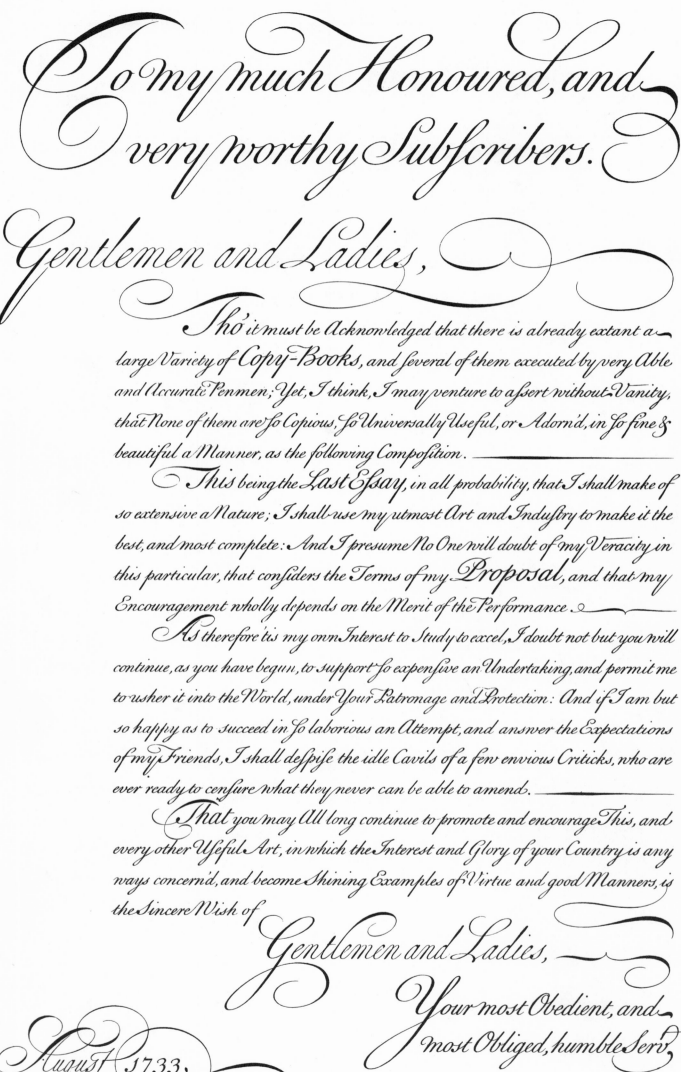

4

To my much Honoured, and Every worthy Subscribers.

Gentlemen and Ladies,

Tho' it must be Acknowledged that there is already extant a large Variety of Copy-Books, and several of them executed by very Able and Accurate Penmen; Yet, I think, I may venture to assert without Vanity, that None of them are so Copious, so Universally Useful, or Adorn'd, in so fine & beautiful a Manner, as the following Composition. ———

This being the Last Essay, in all probability, that I shall make of so extensive a Nature; I shall use my utmost Art and Industry to make it the best, and most complete: And I presume No One will doubt of my Veracity in this particular, that considers the Terms of my Proposal, and that my Encouragement wholly depends on the Merit of the Performance ———

As therefore 'tis my own Interest to Study to excel, I doubt not but you will continue, as you have begun, to support so expensive an Undertaking, and permit me to usher it into the World, under Your Patronage and Protection: And if I am but so happy as to succeed in so laborious an Attempt, and answer the Expectations of my Friends, I shall despise the idle Cavils of a few envious Criticks, who are ever ready to censure what they never can be able to amend. ———

That you may All long continue to promote and encourage This, and every other Useful Art, in which the Interest and Glory of your Country is any ways concern'd, and become Shining Examples of Virtue and good Manners, is the Sincere Wish of

Gentlemen and Ladies, ———

Your most Obedient, and most Obliged, humble Serv.

August 1733,

G: Bickham.

A Poem, On the Universal Penman: By Mr. John Bancks.

Whether the Memphian Priests, or Hebrew Sage,
First painted Language on the leafy Page;
The vast Invention doubtless came from Heav'n,
And with it half Humanity was giv'n.

Hail happy Art! to Science near ally'd,
The Scholar's Treas'ry, and the Merchant's Guide:
Learning, thro' thee, descends to distant Times,
And Commerce travels o'er remotest Climes:
Thou chain'st Events which Ages widely part,
Convey'st the Lover's Wish, reliev'st the lab'ring Heart.

But Use alone was what they first pursu'd,
The Characters were few; their Figures rude.
Succeeding Masters heighten'd up th'Intent;
Gave the free Stroke, and added Ornament.

Last rose th'Engraver's imitating Skill,
That trac'd them off, and multiply'd at will.
Both Arts in Britain now unrivall'd dwell;
Still the last excellent, we ever most excel.

Hail happy Artists! for each other born,
Whose Works, united, mutually adorn.
Till Bickham's Age such Penmen had not been;
Till theirs, like his no Hand was ever seen.
With Rules so just, Examples so refin'd,
So aptly chose, and various in their kind,
They leave no Room to emulate their Art;
For sure, a Plan thus finish'd in each Part,
No future Age shall give, no former gave;
What They alone could write, He only could engrave.

Bickham Sculpsit.

6

To the

Writers of the Universal Penman

Gentlemen

As every Art is more or less Valuable in proportion to its extensive Usefulness, so the Art of Writing claims our highest Esteem, it being One of the greatest Blessings Man can Enjoy: Every Attempt therefore to improve and bring it nearer to Perfection, as 'tis a Publick Good, is doubtless intitled to a Publick Encouragement.

And, as I have been favour'd with your friendly Assistance in Compleating my Universal Penman, I question not but it will meet with the desir'd Success; and answer in every particular the Expectations of the Curious.

The whole having met with the Approbation of the best Judges, I take this Opportunity to pay You my grateful Acknowledgments for Assisting me therein; and shall always Esteem it as a particular Favour conferr'd on

Gentlemen

Your most Obliged
humble Servant,

London

12 August 1741.

G Bickham

THE
Table of Contents to the Universal Penman.

Note. Agreeable to this Table, the After-Pages, &c. must remain in the Numbers as they are already plac'd.

THE

Universal Penman.

INTRODUCTION.

The Use of the Pen is of so great Importance to Mankind in general, and so indispensably necessary for the Man of Business, that I think it needless to make any Apology for the Publication of this Work——

However, since something may be expected, by way of Preface, to a Book so Useful and Entertaining; I shall take the Liberty to transcribe y.e Thoughts of a very ingenious Author on this Occasion; which I imagine will not only be instructive, but also very applicable to my present Undertaking. ——

WRITING is the first Step, and Essential in furnishing out the Man of Business. And this Qualification is more excellent, as 'tis more useful in Business, and beautiful to the Eye, & may not improperly be consider'd in two Respects, as it proceeds from the Eye and the Hand; From the one, we have Size and Proportion; From the other, Boldness and Freedom. For as the Exactness of the Eye fixes the Heights and Distances; so the Motion of the Joints, and Position of the Hand, determine the black and fine Strokes, and give the same Inclination and Likeness in the Standing & Turn of the Letters.

But, in Order to write well, there must be just Rules given, and much Practice to put 'em in Execution. Plain, Strong, and neat Writing, as it best answers the Design for Use and Beauty; so it has most obtain'd among Men of Business. A full, free, open Letter, struck at once, as it discovers more of Nature, so it gives a Masterly Beauty to the Writing; to which may be added such ornamental

Turns

Turns of the Pen, as seem rather design'd to fill up Vacancies on the Paper, than studiously compos'd to adorn the Piece. In Flourishing the Fancy would be so Luxuriant, was it not corrected by the Judgment, as almost to destroy the End of Writing; as Airs in Musick, when too often repeated, or too long or too variously performed, disorder the Harmony of a just Composure.

But, as above, if Usefulness and Beauty are the Excellencies of Writing; that which will, with the greatest Facility, contribute to these, is the best Method of Teaching. Supposing, therefore, the Make and Proportion of the Letters and Joinings to be once well fixed and understood, and then if the Learner is us'd to copy the great Variety of Examples which are here produc'd, his Hand will grow confirm'd in an Aptitude and Readiness, which will insensibly arrive at Perfection and Dispatch; and give in Writing, what we admire in fine Gentlemen; an Easiness of Gesture, and disengag'd Air, which is imperceptibly caught from frequently conversing with the Polite and Well-bred.

DRAWING is another necessary Qualification, and therefore I have attempted to make the Decorations of this Work fit for the imitation of those, whose Genius prompts them to the Study of that Art.

But as Writing is the most Useful Accomplishment of y̌ two, I have given a larger Number of Specimens for that purpose; Exhibited in Precepts Divine and Moral, with many Examples in Trade and Business.

And as the Whole is compleated, through y̌ friendly Assistance of several Eminent Penmen, and Engrav'd with the greatest Care and Exactness; I make no doubt but it will meet with a favourable Reception from the Publick; & that I my Self shall be excus'd for attempting so Universal a Performance.

G. Bickham.

N.º 2.

READING and WRITING.

By the Arts of Reading and Writing, we can Sit at Home and acquaint our selves with what is done in all the distant Parts of the World, & find what our Fathers did long ago in the first Ages of Mankind.

The Art of Letters does, as it were, revive all the past Ages of Men and Sets them at once upon the Stage; and brings all the Nations from afar, and gives them, as it were, a general Interview; so that the most distant Ages of Mankind may converse together, and grow into Acquaintance.

Among all the Inventions of Mankind none is more Admirable, necessary, useful or convenient than Writing, by which a Man is enabled to delineate his very Conceptions, communicate his Mind without Speaking, and correspond with his Friend at ten thousand Miles distance, and all by the Contrivance of twenty four Letters. Viz.t Aabc &c.

For
Mr. Geo. Bickham.

Sir,

I if any thing could excite me to think well of my own Judgement in the Art of Penmanship, it would be your desiring me to Assist you in the Writing some part of yo.r New Copy Book.

As your Design is both Laudable & Useful, I willingly embraced the Opportunity of serving You, and have therefore Sent You a Page on the Art of Writing, & as you Approve of that I shall be ready to do you Farther Service

That a Work of this Nature hath been Long wanted admits of no Exception, and yo.r Abilities to execute it are too well known to need any Recommendation; What you have Engrav'd for my Late celebrated Master, Mr. Charles Snell, & several other eminent Penmen are sufficient Testimonies.

Nothing, in my Opinion, can be more Advantageous to the Publick than the Work You are at present engaged in, and that your Labours may meet with Encouragement equal to your Merit is the Hearty Desire of

Sir,

Your very humble Serv.t

London
August 8.th, 1733.

J. Champion

On the Art of Writing.

Hail mistick Art! which Men like Angels taught,

To speak to Eyes, and paint unbody'd Thought!

Tho' Deaf, and Dumb; blest Skill, reliev'd by *Thee*,

We make one Sense perform the Task of Three.

We see, we hear, we touch the Head and Heart,

And take, or give, what each but yields in part.

With the hard Laws of Distance we dispence,

And without Sound, apart, commune in Sense;

View, tho' confin'd; nay, rule this Earthly Ball,

And travel o'er the wide expanded *All*.

Dead Letters, thus with Living Notions fraught,

Prove to the Soul the Telescopes of Thought;

To Mortal Life a deathless Witness give;

And bid all Deeds and Titles last, and live.

In scanty Life, *Eternity* we taste;

View the First Ages, and inform the Last.

Arts, Hist'ry, Laws, we purchase with a Look,

And keep, like *Fate*, all Nature in a *Book*.

Josephus Champion Scripsit.

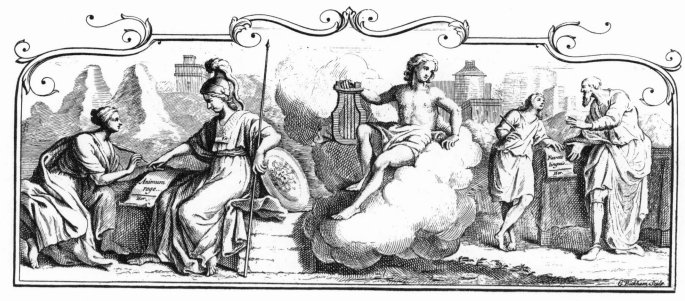

EDUCATION.

A human Soul without Education is like Marble in the Quarry, which shews none of its inherent Beauties till the skill of the Polisher fetches out the Colours, and discovers the ornamental Clouds that run thro' the body of it. Education draws out to View every latent Virtue w.ch without such Helps would never be able to make their Appearance.

We rise above one another in ye Esteem of ye World by different degrees of Perfection, proportion'd to the Want or Advantage of a liberal Education.

The care of Education is a work of ye highest Moment, as all ye Advantages or Miscarriges of a Man's Life, are in a great Measure dependent on it. 'Tis ye Duty therefore of Parents to infuse into ye untainted Youth early notices of Justice & Honour, that so ye possible Advantages of good Parts, may not take an Evil turn, or be perverted to base & unworthy purposes.

William Leekey scrip.

Education.

Children, like tender Oziers, take the Bow,
And as they first are fashion'd always grow:
For what we learn in Youth, to that alone
In Age we are by second Nature prone.

All Youth, set right at first, with Ease go on,
And each new task is with new pleasure done;
But if neglected till they grow in Years,
And each fond Mother, her dear Darling spares,
Error becomes habitual, and you'll find,
'Tis then hard Labour to reform the Mind.

Youth like the soften'd Wax with ease will take
Those Images that first Impressions make
If those are fair their Lives will all be bright
If foul they'll cloud it all with Shades of night.

Willington Clark script.

Education

'Tis Education alone that can mend Nature, & improve the Talents of that great Benefactress. Has she given us a competent Share of Sense and Reason? Education carries up our Sense to Wisdom, and our Reason to Judgment. Ab.

Education is ye Learned Alchymist that purges away our Dross & sublimes our Dispositions: That reads us Lectures of Use upon every turning and winding of our Actions; informs us in our general and particular Duties; teaches us to worship Heaven, to honour our Parents, to reverence our Elders, to subject our selves to the Laws, to obey our Governors, to love our Friends, to cherish our Wives, be affectionate to our Children, and not injurious to any.

Education strikes in with Philosophy in many lessons; teaches us not to be over-joy'd in Prosperity, nor too much dejected in Adversity; not to be dissolute in our Pleasures, nor in our Anger to be transported to a Fury that is Brutal. Wxyz

Command of Hand.

Sure in its Flight, tho' swift as Angels Wings;
The Pen commands; & the bold Figure springs:
While the slow Pencil's discontinu'd Pace,
Repeats the Stroke; but cannot reach the Grace.

How justly Bold, when in some Master's Hand;
The Pen at once joins Freedom with Command!
With Softness strong, with Ornaments not vain;
Loose with Proportion, and with Neatness plain;
Not swell'd, yet full, compleat in ev'ry Part;
And Artful most, when not affecting Art.

O'er Virgin-Paper when the Hand we trace,
How new, how Free, how perfect ev'ry Grace!
So smooth, so fine, the nimble strokes we view,
Like Trips of Fairies o'er the Morning-Dew.

J. Champion Scrip.

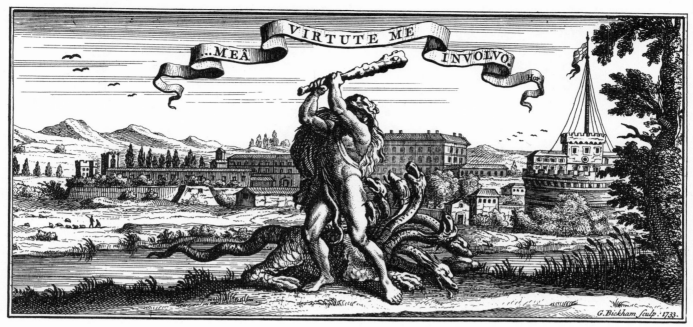

MEA VIRTUTE ME INVOLVO

G. Bickham Sculp. 1733.

VIRTUE.

As Virtue in general is of an amiable and lovely Nature, there are some particular kinds of it which are more so than others, and these are such as dispose us to do good to Mankind. Temperance and Abstinence, Faith & Devotion, are in themselves perhaps as laudable as any other Virtues, but those w.ch make a Man popular & belov'd, are Justice, Charity, Munificence, and in short, all ÿ good qualities ÿt render us beneficial to each other.

The two great ornaments of Virtue, which shew her in the most advantagious View, and make her altogether lovely, are Chearfulness and Good Nature. These generally go together, as a Man cannot be agreeable to others who is not easy within himself. These are both very requisite in a virtuous mind, to keep out Melancholy from the many serious Thoughts it is ingaged in, and to hinder it's natural hatred of Vice from sow'ring into Severity and Censoriousness.

W. Clark scrip.

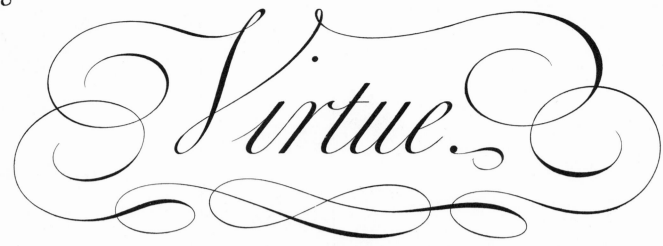

With glittering Beams & native Glory bright,
Virtue, nor Darkness dreads, nor covets Light;
But from her settled Orb looks calmly down,
On Life or Death, a Prison or a Crown.

Virtue's the chiefest Beauty of the Mind,
The noblest Ornament of Human-kind;
Virtue's our Safeguard, & our guiding Star,
That stirs up Reason, when our Senses err.

True Sons of Virtue, mean Repulse disdain,
Nor does their shining Honour ever stain;
Their glorious Minds are so securely great,
They neither swell, nor sink at turns of Fate.

W.ᵐ Leekey Script.ᵗ

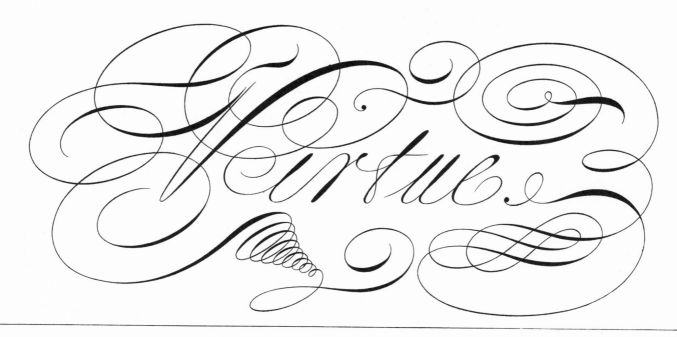

Virtue

Virtue's the Friend of Life, the Soul of Health;
The poor man's Comfort, & the rich man's Wealth.

Virtue & Friendship above all things
purchase to men Love and Good-will.

Virtue has Secret Charms which all Men Love,
And those that do not choose her, yet approve.

Virtue and Arts are attained by
frequent Practice & Perseverance.

By Virtuous Use thy Life and Manners frame,
Manly and Simply pure, and free From Blame.

J. Champion Script.
1733.

ADVICE.

Learn to contemn all praise betimes;
For flattery's the nurse of Crimes.

Seek you to train your fav'rite Boy?
Each Caution, ev'ry Care employ;
And ere you venture to confide,
Let his Preceptor's heart be try'd;
Weigh well his manners, life, & Scope,
On these depends thy future hope.

With early Virtue plant thy breast,
The specious Arts of Vice detest.

W. Clark scrip.^t

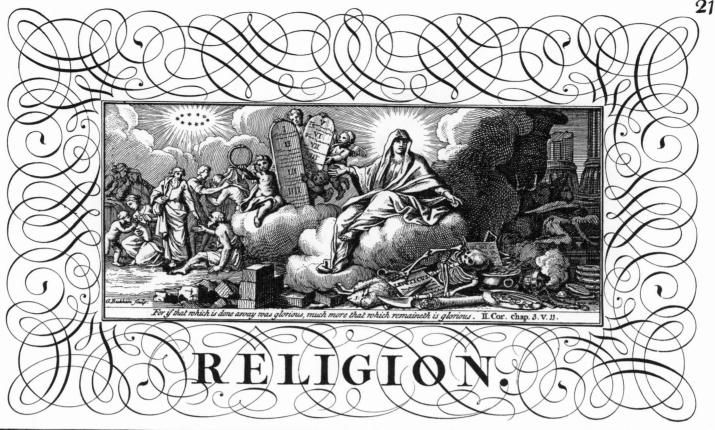

For if that which is done away was glorious, much more that which remaineth is glorious. II. Cor. chap. 3. v. 11.

RELIGION.

Moral Virtues themselves without Religion are but cold, lifeless & insipid: 'Tis that which opens the Mind to great Conceptions, fills it with the most sublime Ideas, and warms the Soul more than sensual Pleasures.

Glory of God, Man's Good, are the fix'd Poles
On which the Sphere of true Religion rolls

Religion better qualifies all sorts of Men, and makes them in publick Affairs the more service-able; Governors apter to rule w.th Conscience, and Inferiors for Conscience sake more willing to obey.

W. CLARK SCRIPSIT.

Religion.

Hail! gentle PIETY! unmingled joy!
Whose fulness Satisfies, but ne'er can cloy!
Spread thy soft Wings o'er my devoted breast,
And settle there an everlasting Guest.

Let homage be to pure *Religion* paid,
Seek her Protection, and implore her Aid;
That she may keep thy Soul from harm secure,
And turn thy Footsteps from the Harlot's door.
Who with curs'd Charms lures the unwary in,
And sooths with Flattery their souls to Sin.

Religion prompts us to a Future State;
The last appeal from Fortune & from Fate:
Where God's all-righteous way will be declar'd,
The bad meet Punishment, the good Reward.

Joseph Champion Scripsit.

Religion.

The commands of Heaven, in the observance of which Religion principally consists, are very plain & obvious to the meanest Understanding; and are nothing else but Exhortations to Love, and directions for social Happiness.

Great is the steadiness of Soul and Thought,
By Reason bred, and by Religion taught:
Which like a Rock amidst yᵉ stormy Waves,
Unmov'd remains, and all Afflictions braves.

Divine worship is that which distinguishes us from the Brutal part of the creation, more than that ray of the Divinity our reason it self: For they frequently discover some Affinity to the one, but in no one Action whatsoever betray the least Resemblance to the other.

B. Whilton Scripsit

1734.

Wisdom, and Beauty.

There is nothing which gives one so pleasing a Prospect of human Nature, as the Contemplation of Wisdom and Beauty: The latter is peculiar to that Sex which is therefore called Fair, & when both meet in the same Person the Character is lovely and desirable.

Beauty, like Ice, our Footing does betray:
Who can tread sure on the smooth slipp'ry Way?
Pleas'd with the Passage we slide swiftly on,
And see the Dangers which we cannot shun.

Wisdom is glorious and never fadeth away, yet she is easily seen of them that love her, and found of such as seek her: For she goeth about seeking such as are worthy of her, sheweth her self favourably unto them in the Way, and meeteth them in every Thought.

W. Leekey scrip.ᵗ

N.º V.

THEODORICK,

KING *of the* GOTHS, &c.

TO

BOETIUS.

You have so well improv'd your Self Abroad in the Athenian Schools, & so familiariz'd the Roman Student with the Grecian Tutors, that their Learning is, by your Means, become Naturaliz'd at Rome: whatever the Athenians had Monopoliz'd you have made Common to the Romans, who are beholden to your laborious Translations, that they can now Read the Musick of Pythagoras, the Astronomy of Ptolemy, the Arithmetick of Nicomachus, the Geometry of Euclid, the Divinity of Plato, the Logick of Aristotle, and the Mechanicks of Archimedes in the Latin Tongue: All which you have adorn'd with so much beauty of Language, & illustrated with so great propriety of Expression, that even the Original Authors, did they equally Understand both Idioms, would prefer your Work to their own.

George Bickham, Fecit. 1734.

Nᵒ VI.

Learning.

How pleasant, and how sweet it is, to see

Riches and Grandeur mixt with Decency!

But much more Sweet, thy lab'ring Steps to guide,

To Vertue's heights, with Wisdom well supply'd,

And all the Magazines of Learning fortify'd.

A little Learning is a dangerous Thing,

Drink deep, or taste not the Pierian Spring.

There shallow Draughts intoxicate y Brain,

And drinking largely sobers us again.

Fir'd with the Charms fair Science does impart,

In fearless Youth we tempt the Heights of Art.

While from the bounded Level of our Mind,

Short Views we take, nor see the Lengths behind.

But more advanc'd behold with strange Surprize,

New, distant Scenes of endless Science rise.

Willington Clark, scrip.

LEARNING.

The Design of Learning, is either to render a Man an agreeable Companion to himself, and teach him to support Solitude with Pleasure; or, if he is not born to an Estate, to supply that Defect, and furnish him with the Means of getting one.

Look cautious round; your Genius nicely know, And mark how far its utmost Stretch will go.

Nobility, Riches, State, and Supremacy can procure us a customary Respect, & make us the Idols of an unthinking Croud; but Knowledge and Learning alone recommend us to the Love of those in a superior Class, who admire more the Merits of our Understanding, than the Advantages of our Birth & Fortune.

Samuel Vaux script.

Learning.

Aristippus, being asked wherein the Learned differed from the Unlearned, said, Send them Naked to Strangers, and you shall see. am

Aurelius used to say, he would not part with the little he had learned for all the Gold in the World; and that he had more Glory from what he had read and written, than from all the Victories he had won, and all the Realms he had conquered.

Learning is Silver in the Hands of Common People, Gold in those of Noble Descent, but Diamonds in the Hands of Princes. aam

Will.ᵐ Leekey,

Scripsit.

THE
Penman's Advice

To Young Gentlemen.

Ye British Youths, our Age's Hope & Care,
You whom the next may polish, or impair;
Learn by the Pen those Talents to insure,
That fix ev'n Fortune, & from Want secure;
You with a dash in time may drain a Mine,
And deal the Fate of Empires in a Line;
For Ease and Wealth, for Honour & Delight,
Your Hand's yo.r Warrant, if you well can Write.
"True ease in Writing comes from Art, not Chance;
"As those move easiest, who have learn'd to Dance.

To Young Ladies

Ye springing Fair, whom gentle Minds incline,
To all that's curious, innocent, and fine!
With Admiration in your Works are read
The various Textures of the twining Thread.
Then let the Fingers, whose unrivall'd Skill,
Exalts the Needle, grace the Noble Quill.
An artless Scrawl y.e blushing Scribler shames;
All shou'd be Fair that Beauteous Woman frames.
Strive to excell, with Ease the Pen will move;
And pretty Lines add Charms to infant Love.

Samuel Vaux scrip.

17 34.

Study.

Aristotle says, that to become an able Man in any profession, three things are necessary; that is to say, Nature, Study, and Practice.

He most improves who Studies with Delight, And learns sound Morals whilst he learns to write.

Make the Study of the sacred Scriptures your daily Practice, and principal Concern; and embrace the doctrines contained in them, as the Oracles of Heaven, and the Dictates of that Spirit which cannot lie. June 2.

W. Clark Scripsit.

The whole Universe is your Library:
Authors, Conversation, & Remarks
upon them, are your best Tutors.

There is not a wider Difference betwixt Man and Beast than betwixt Man
and Man. And to what is this Difference owing, but to the Distinguisht
Improvements of the Mind by Study and Meditation? without these
Helps, no Distinction of Faculties will render us Conspicuous. 1734

Study to be Eminent. Mediocrity is below a
brave Soul. Eminency in Knowledge conjunct
with equal Goodness will be to you of all others
the most commendable Distinction. May. 16.

B. Whilton script.

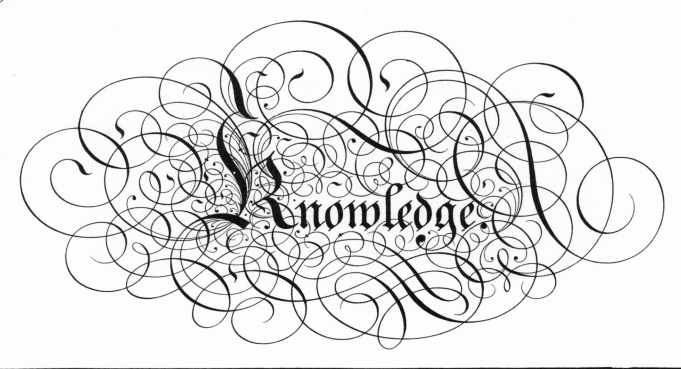

Knowledge

Knowledge, softened with Complacency and good Breeding, will make a Man equally belov'd and admired; but being join'd with a severe and morose Temper, it makes a Man rather fear'd than respected.

From Art and Science true Contentment flow; For 'tis a Godlike Attribute to know.

Knowledge is that which next to Virtue truely and essentially raises one Man above another; it finishes one half of the human Soul; it makes Beings pleasant to us; it fills the Mind with entertaining Views, & administers to it a perpetual Series of Gratifications; it gives ease to Solitude, & a gracefulness to Retirement; it fills a Publick Station with Suitable Abilities, & adds a Luster to those who are in possession of them.

William Brooks Scrip:

נֵהוֹרָא

Knowledge comes from Above

KNOWLEDGE.

In Nature's Search we to the Cause advance;
But Knowledge must inform our Ignorance:
To judge of Arts we must their Objects know,
And from the Current to the Spring we go.

Merit should be for ever plac'd
In Knowledge, Judgment, Wit, & Taste;
For these, 'tis own'd, without dispute,
Alone distinguish Man from Brute.

Knowledge, by Time, advances slow and wise,
Turns ev'ry where its deep-discerning Eyes;
Sees What befel, and What may yet befal;
Concludes from Both, & best provides for All.

E. Austin scripsit.
1734.

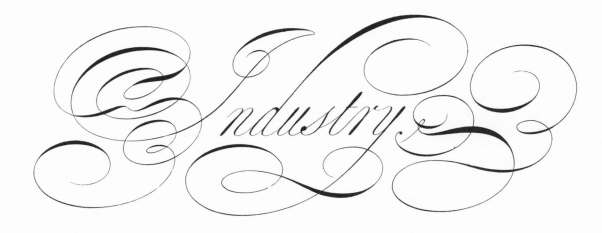

Industry

Flee Sloth, the Canker of good Men, and Parts,
Of Health, of Wealth, of Honour, and of Arts.
Such as court Fame must not their senses please,
Her Chariot lags when drawn by Sloth and Ease.

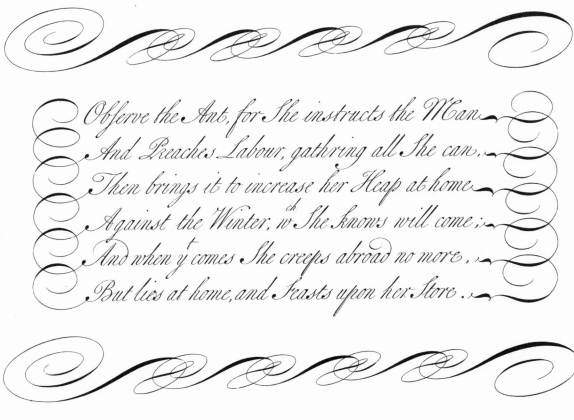

Observe the Ant, for She instructs the Man
And Preaches Labour, gathring all She can,
Then brings it to increase her Heap at home
Against the Winter, w^ch She knows will come;
And when y^t comes She creeps abroad no more,
But lies at home, and Feasts upon her Store.

Quickly lay hold on time, while in your Power;
Be careful well to Husband ev'ry Hour
Despair of Nothing which you wou'd attain,
Unweary'd Diligence your point will gain.

Samuel Vaux scr:

1734

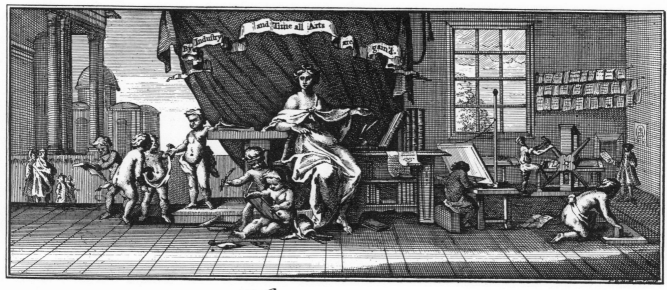

Induſtry

So true to Induſtry, and so zealous for Employment have wiſe Men been in all Ages, that they have look'd upon Idleneſs and Inactivity as Crimes of a heinous Nature, and thoſe who have search'd into Human-Nature obſerve, that nothing so much shews the Nobleneſs of Soul, as ỹ it's Felicity conſists in Action.

Industry is needful in every condition of Life; we cannot without it act in any State decently, or usefully, either to the benefit or satisfaction of others, or to our own Advantage or Comfort; it is requiſit for procuring Ease Sweet and Satisfaction to the Mind, attended with a good Conſcience, sweetens our Enjoyments, and seaſons our Attainments, is a Guard to Innocence and a Bar to Temptations.

W. Clark scripsit.

IN TENUI LABOR.

Idleness.

If we look back into the Old World, we shall find that all its Vigour was owing to Exercise, Sprightliness, and Activity: Luxury & Idleness, first debilitated, & impair'd ÿ strength of Nature.

The first Physicians by Debauch were made,
Excess began and Sloth sustains the Trade.
By Chace our Long-liv'd Fathers earn'd their Food,
Toil strung the Nerves and purify'd the Blood.

Action keeps the Soul in constant Health, but Idleness corrupts, and rusts the Mind; for a Man of great Abilities may by Negligence & Idleness become so mean & despicable, as to be an Incumbrance to Society, and a Burthen to himself.

Gabriel *Idleness* Brooks

Scripsit.

THE

Writing Masters

INVITATION, *AND* INSTRUCTION.

Come Youths this Charming Sight behold!
With Laurel Plum'd, a Pen of Gold!
If You would win this Glorious Prize,
Do as Your Master shall Advise;
Till You, from Learners, Masters grown,
Make both the Bays & Gold your Own.

Come Listen Youths, and I'll Display
To this Rare Art a Certain Way.
He that in Writing would Improve,
Must first with Writing fall in Love;
For True Love for True Pains will call,
And that's the Charm that Conquers All.

Three things bear mighty Sway with Men, ||| Who can the least of these Command,
The Sword, the Scepter, and the P E N; ||| In the First Rank of Fame will Stand.

Labor Omnia Vincit

J. Champion delin. et scrip.

Nº. IX.

Honesty.

An Honest Mind, safely alone,
May travel thro' the burning Zone;
Or thro' the deepest Scythian Snows,
Or where the fam'd Hydaspes flows.

Honesty, could it be discerned by our naked
Eye, would, in the Opinion of Plato, win
us to an Inexpressible Love of Wisdom.

Convince the World that you're devout, & true,
Be just in all you Say, and all you Do;
Whatever be your Birth, you're sure to be
A Peer of the first Magnitude to Me.

J. Oldfield scripsit.

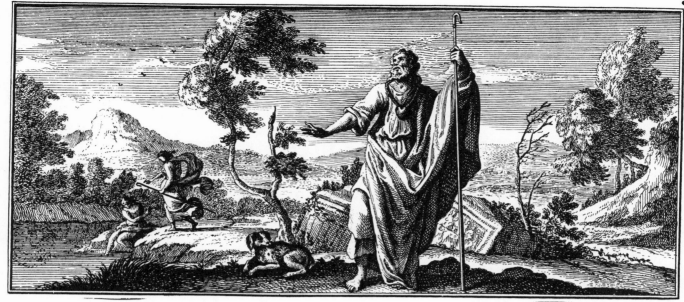

HONESTY.

An honest Man's Dealings are square and above-board; he discovers the Faults of what he would sell; restores the over-seen Gain of a false Reckoning; and esteems a Bribe venemous, tho' it comes gilded over with the Colour of Gratuity.

Short is the Date in which ill Acts prevail,
But Honesty's a Rock can never fail.

The Cheeks of an honest Man are never stain'd with the Blushes of Recantation; nor does his Tongue faulter to make good a Lye, with the secret Glosses of a double or reserv'd Sense. His fair Conditions are without Dissembling, and he loves Actions above words; hates falshood worse than Death; is a faithful Client of Truth and no Man's Enemy.

John Day scrip.

Discretion.

Discretion does not only shew it self in Words, but in all the Circumstances of Action, and is like an Under-Agent of Providence to guide and direct us in the ordinary Concerns of Life.

If we look into particular Communities & Divisions of Men, we may observe that it is the Discreet Man not the Witty, nor the Learned, nor the Brave who guides the Conversation, and gives Measures to the Society.

There are many shining Qualities in the Minds of Men, but there is none so useful as Discretion; it is this indeed which gives a Value to all the rest, which sets them at Work in their proper Times and Places, & turns them to the Advantage of the Person who is possessed of them.

Gabriel Brooks, scripsit.

Falshood.

Whatsoever Convenience may be thought to be in Falshood
and Dissimulation, it is soon over; but the Inconvenience of
it is perpetual, because it brings a Man under an everlasting
Jealousy and Suspicion; so that he is not believ'd when he
speaks Truth, nor trusted when, perhaps, he means Honestly.

Let Justice o'er thy Word and Deed preside;
And Falshood shun as a Deceitful Guide.

An Untruth in Discourse is a Disagreement between the Speech and the
Mind of the Speaker. When one thing is Declar'd and another Meant,
words are no Image of the Thoughts: it makes the Marks of Speech insig-
nificant, and the Meaning of one Man unintelligible to another; this is a breach
of the Article of Commerce, and an Invasion upon the Rights of Society.

John Shortland Scrip.

Nᵒ. X.

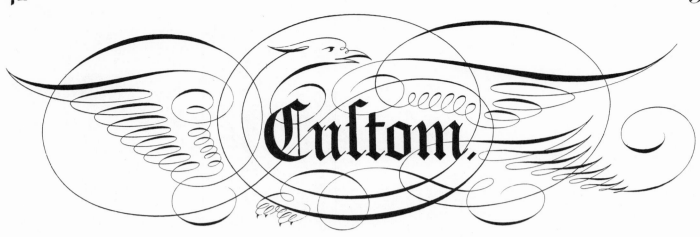

Custom.

Pitch upon that Course of Life which is most excellent, & Custom will make it the most delightful.

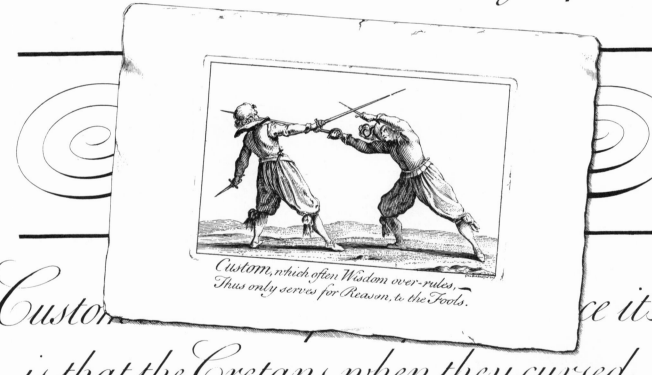

Custom, which often Wisdom over-rules,
Thus only serves for Reason, to the Fools.

Custom ... ce it is that the Cretans, when they cursed their Enemies, wish'd that they might be delighted with an evil Custom. 1734.

Clark scrip.t

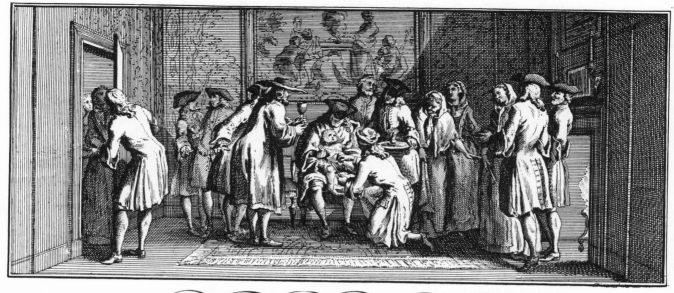

CUSTOM.

Ill Customs by Degrees to Habits rise,
Ill Habits soon become Exalted Vice.
Ill Customs gather by Unseen Degrees,
As Brooks make Rivers, Rivers swell to Seas.

Let the best course of Life your choice invite,
For Custom soon will turn it to Delight.

Do not Repine at what you now Endure,
Custom will give you Ease, or time a Cure.
For Custom of some date, my Friend, foregoes
Its proper Shape, and second Nature grows.

Champion Scripsit.

44

Swearing

Don't bind your self to what you cannot do,
And never Swear, altho' the Thing be true;
For 'tis a Wicked and a great Offence,
To call on God for each Impertinence.

Oaths are no Ornament to Conversation,
for instead of Beautifying it, they make
it most Contemptible and mean. Aabcd.

Of all the nauseous complicated Crimes,
That both infect and stigmatize the Times;
There's none y' can with impious Oaths compare,
Where Vice and Folly have an equal share.

B. Whilton scrip.

MODESTY.

A just and reasonable Modesty does not only recommend Eloquence, but sets off ev'ry great Talent which a Man can be possessed of. It heightens all the Virtues w.ᶜʰ it accompanies, like the Shades in Paintings, it raises and rounds every Figure, and makes the Colours more beautiful tho'not so glaring as they would be without it.

Immodest Words admit of no defence,
For want of Decency is want of Sense.

Modesty is not only an Ornament, but also a Guard to Virtue. It is a kind of quick and delicate feeling in the Soul, which makes her shrink and withdraw her self from every thing that has Danger in it. It is such an exquisite Sensibility as warns her to shun y.ᵉ first appearance of every thing which is hurtful.

In modest Actions there are certain Rules,
Which to transgress confirms us Knaves or Fools.

Gabriel Brooks

Modesty is a Check to Vice.

scripsit.

Nᵒ. XI.

Good-Nature.

Indulgence soon takes with a noble Mind,

Who can be harsh that sees another kind?

Mildness and Temper have a Force divine,

To make ev'n Passion with their Nature join.

Love, rais'd on Beauty, will like that decay,

Our Hearts may bear its slender Chains a Day,

As flow'ry Bands in Wantonness are worn,

A Morning's Pleasure, and at Ev'ning torn ;

Good-Nature binds more easy, yet more strong

The willing Heart, and only holds it long.

Trust not too much your now resistless Charms,

Those, Age, or Sickness, soon or late disarms:

Good-Nature only teaches Charms to last,

Still makes new Conquests, and maintains ÿ past.

E. Austin Scripsit.

Good-Nature.

Good-Nature is the Foundation of all Virtues, either
Religious or Civil; Good-Nature, which is Friendship between
Man and Man, good Breeding in Courts, Charity in
Religion and the true Spring of all Beneficence in General.

Good-Nature and good Sense must ever join;
To err is Human, to Forgive, Divine.

Good Sense and Good-Nature are never separated, tho' the ignorant World
has thought otherwise; Good-Nature, by which I mean Beneficence and Candor,
is the Product of right Reason, which of necessity will give allowance to the
Failings of others, by considering that there is nothing perfect in Mankind.

W: Kippax Script.

Envy, and Detraction.

Envy will Merit as its shade pursue;
But like a Shadow proves the Substance true.
ffor envy'd Wit, like Sol eclips'd, makes known
Th' opposing Body's grossness, not its own.

Keep no Company with a Man, who is given to Detraction;
to hear him Patiently, and shew a Countenance of Encourage-
ment is to partake of his Guilt, and prompt him to a Continu-
ants' in that Vice, which all good Men should shun him for.

There is a Lust in Man no Charm can tame,
Of loudly publishing his Neighbour's Shame;
On Eagles Wings Immortal Standals flie,
While Virtuous Actions are but born and die.

Josephus Champion Scripsit.

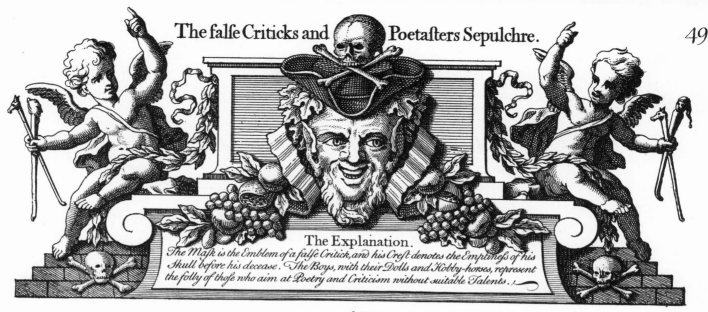

The false Criticks and Poetasters Sepulchre.

The Explanation.
The Mask is the Emblem of a false Critick, and his Crest denotes the Emptiness of his Skull before his decease. The Boys, with their Dolls and Hobby-horses, represent the folly of those who aim at Poetry and Criticism without suitable Talents.

A Simile, or Comparison.

Dear Thomas didst thou never pop
Thy Head into a Tinman's Shop;
There, Thomas, didst thou never see,
('Tis but by way of Simile.)
A Squirrel spend his little Rage,
In jumping round a rolling Cage?
The Cage, as either Side turn'd up,
Striking a Ring of Bells a-top?
Mov'd in the Orb, pleas'd w.th y.^e Chimes,
The foolish Creature thinks he climbs;

But here or there, turn Wood or Wire,
He never gets two Inches higher.
So fares it with those merry Blades,
That frisk it under Pindus Shades;
In noble Songs, and lofty Odes,
They tread on Stars, & talk with Gods:
Still dancing in an airy Round,
Still pleas'd with their own Verses sound;
Brought back, how fast so e'er they go;
Always aspiring, always low.

'Tis great Delight to laugh at some Mens Ways;
But a much greater to give Merit Praise.

W. Clark Scrip.

No. XII. 1735

Criticism.

One great Mark, by which you may discover a Critick who has neither Taste nor Learning, is this, that he seldom ventures to praise any Passage in an Author which has not been before received and applauded by the Publick; and that his Criticism turns wholly upon little Faults and Errors. This part of a Critick is so very easie to succeed in, that we find every ordinary Reader, upon y᷎ publishing of a new Poem, has Wit & Ill-nature enough to turn several Passages of it into Ridicule, and very often in y᷎ right Place.

Errors, like Straws, upon the Surface flow;
He who would search for Pearls must dive below.

A true Critick ought to dwell rather upon Excellencies than Imperfections, to discover the concealed Beauties of a Writer, and communicate to the World such things as are worth their Observation. The most exquisite Words and finest Strokes of an Author, are those which very often appear the most doubtful and exceptionable, to a Man who wants a Relish for polite Learning; and they are these, w.[ch] a sour undistinguishing Critick generally attacks with y᷎ greatest Violence.

E. Austin Scripsit.

1735.

Criticism.

In Poets, as true Genius is but rare,
True Tast as seldom is the Critick's share;
Both must alike from Heav'n derive their Light;
These born to judge, as well as those to write.

Let such teach others, who themselves excel,
And censure freely, who have written well.
Authors are partial to their Wit, 'tis true;
But are not Criticks to their Judgment too?

A perfect Judge will read each Work of Wit,
With the same Spirit that it's Author Writ;
Survey the Whole, nor seek slight Faults to find,
Where Nature moves, & Rapture warms y Mind.

John Bickham sculp.

A Story,

Out of Boccalini, To the ill-natur'd CRITICKS.

A famous Critick, says he, having gathered together all the Faults of an Eminent Poet, made a present of them to Apollo, who received them very graciously, and resolved to make the Author a suitable Return, for the Trouble he had been at in collecting them. In order to this, he set before him a Sack of Wheat, as it had been just threshed out of the Sheaf. He then bid him pick out the Chaff from among the Corn, & lay it aside by itself. The Critick applied himself to the Task with great Industry and Pleasure, and after having made the due Separation, was presented by Apollo with the Chaff for his Pains.

Whoever thinks a faultless Piece to see,
Thinks what neer was, nor is, Nor eer shall be.

Champion Scripsit.

O Rare Ben: Johnson.

G. Bickham sculp.

WIT, and HUMOUR.

Marble, or Brass, devouring Time may waste,
But Wit, as long as circling Time shall last,
That ever lives, nor can to Death submit;
No Tomb he needs, whose Monument is Wit.

𝔚𝔦𝔱, 𝔩𝔦𝔨𝔢 𝔅𝔢𝔞𝔲𝔱𝔶, 𝔱𝔯𝔦𝔲𝔪𝔭𝔥𝔰, 𝔬'𝔢𝔯 𝔱𝔥𝔢 𝔥𝔢𝔞𝔯𝔱,
𝔚𝔥𝔢𝔫 𝔪𝔬𝔯𝔢 𝔬𝔣 𝔑𝔞𝔱𝔲𝔯𝔢'𝔰 𝔰𝔢𝔢𝔫, 𝔞𝔫𝔡 𝔩𝔢𝔰𝔰 𝔬𝔣 𝔄𝔯𝔱.

True Humour must always lie under the Check of Reason, and it
requires the Direction of the nicest Judgment, by so much y̆ more as
it indulges it self in the most boundless Freedoms. In short, it must
consist in a Pleasantry deriv'd from Nature, in Vivacity and Mirth,
without Affectation, bounded by Truth, and supported by good Sense.

E. Austin Scripsit.

Nᵒ. XIII. Mdccxxxv.

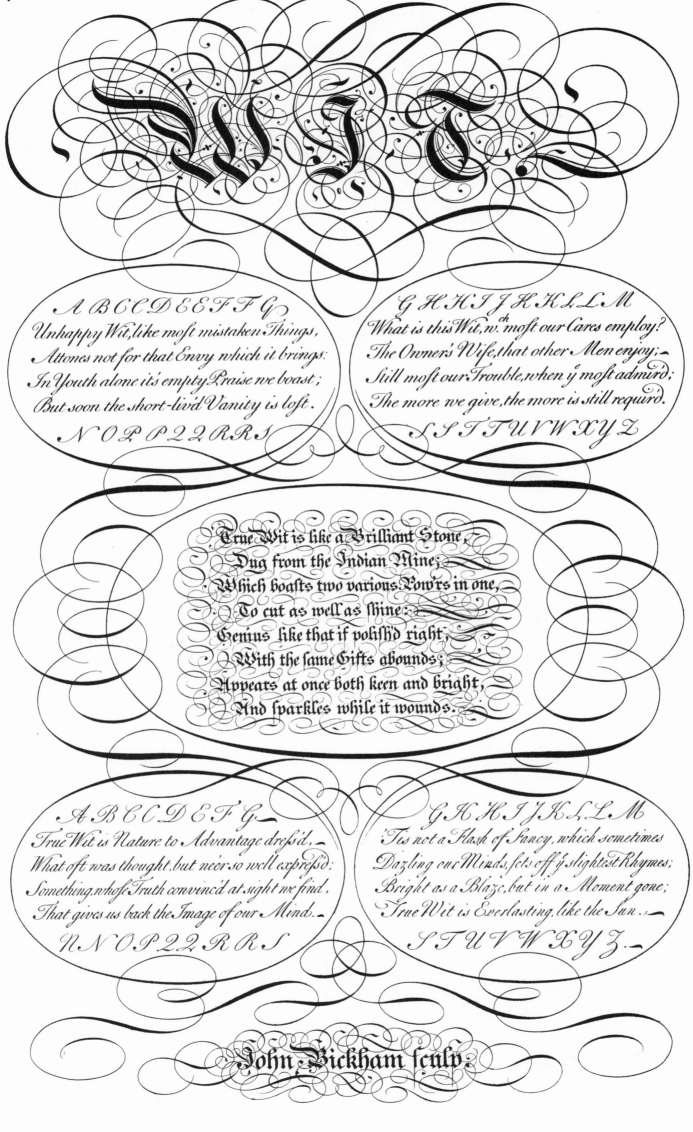

WIT.

A B C C D E E F F G
Unhappy Wit, like most mistaken Things,
Attones not for that Envy which it brings:
In Youth alone it's empty Praise we boast;
But soon the short-liv'd Vanity is lost.
N O P P 2 2 R R S

G H H I J K L L M
What is this Wit, w.ch most our Cares employ?
The Owner's Wife, that other Men enjoy;
Still most our Trouble, when y most admir'd;
The more we give, the more is still requir'd.
S S T T U V W X Y Z

True Wit is like a Brilliant Stone,
Dug from the Indian Mine;
Which boasts two various Pow'rs in one,
To cut as well as shine:
Genius like that if polish'd right,
With the same Gifts abounds;
Appears at once both keen and bright,
And sparkles while it wounds.

A B C C D E F G
True Wit is Nature to Advantage dress'd,
What oft was thought, but ne'er so well express'd;
Something, whose Truth convinc'd at sight we find,
That gives us back the Image of our Mind.
N N O P 2 2 R R S

G H H I J K L L M
'Tis not a Flash of Fancy, which sometimes
Dazling our Minds, sets off y slightest Rhymes;
Bright as a Blaze, but in a Moment gone;
True Wit is Everlasting, like the Sun.
S T U V W X Y Z

John Bickham sculp.

Laughter

Man is the merriest Species of the Creation, all above and below him are Serious. He sees things in a different Light from other Beings, & finds his Mirth rising from Objects that perhaps cause something like Pity or Displeasure in higher Natures. Laughter is indeed a very good Counterpoise to the Spleen; and seems but reasonable that we should be capable of receiving Joy from what is no real Good to us, since we can receive Grief from what is no real Evil. April, 11.

Laughter, while it lasts, slackens & unbraces the Mind, weakens the Faculties, and causes a kind of Remissness and Dissolution in all the Powers of the Soul; & thus far it may be look'd upon as a Weakness in the Composition of human nature. But if we consider the frequent Reliefs that we receive from it, & how often it breaks y' Gloom which is apt to depress the Mind, and damp our Spirits with transient unexpected gleams of Joy, one would take care not to grow too Wise for so great a Pleasure of Life.

Joseph Champion Scripsit.

Decency.

The Comeliness of Person and Decency of Behaviour, add infinite Weight to what is pronounc'd by any one. 'Tis the want of this that often makes the Rebukes and Advice of old rigid Persons of no Effect, and leave a displeasure in the Minds of those they are directed to: But Youth and Beauty, if accompanied with a graceful and becoming Severity, is of mighty force to raise, even in the most Profligate, a Sense of Shame. In Milton the Devil is never describ'd asham'd but once, & that at the Rebuke of a Beauteous Angel.

So spake the Cherub, and his grave Rebuke
Severe in youthful Beauty, added Grace
Invincible: Abash'd the Devil stood,
And felt how awful Goodness is, and saw
Virtue in her own Shape how lovely! saw, and
Pin'd his Loss.

Without Decency Valour would degenerate into Brutality, Learning into Pedantry, and the genteelest Demeanour into Affectation. Even Religion it self, unless Decency be the Handmaid which waits upon her, is apt to make People appear guilty of Sourness and ill Humour: But this shews Virtue in her first original Form, adds a Comeliness to Religion, and gives its Professors the justest Title to the beauty of Holiness.

B: Whilton Scrip.

1735.

Friendship.

A Friend should always like a Friend indite,
Speak as he thinks, and as he thinks should write,
Searching for Faults, as he would Beauties find,
To Friendship true, but not to Justice blind.

He that for Int'rest, Friendship does pretend,
Forfeits the Name and Virtue of a Friend.

A Gen'rous Friendship no cold Medium knows,
Burns with one Love, with one Resentment glows.
One should our Int'rests and our Passions be;
My Friend must slight y^e Man that injures me.

E. Austin scripsit.

N°. XIV.

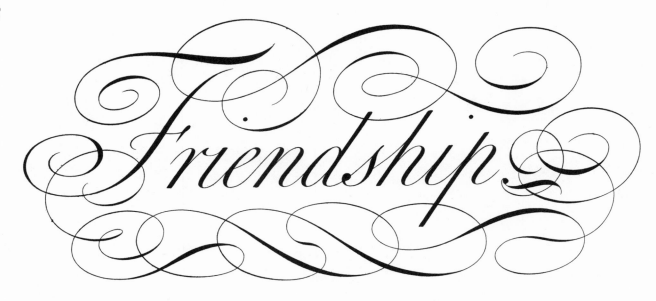

All other things desirable in Life are good as appropriated to some particular.
Money serves our Uses, Riches procure us Respect, Honours gain us Applause,
Pleasures contribute to our Enjoyment of the World; Health secures us against
Pain, and gives us the true use of our Limbs. *Friendship* contains in it a number
of Conveniencies; it is of Service in all Exigencies and Circumstances of Life; is to
be excluded from no Place, or Occasion, can never be Unseasonable, never Troublesome.

Tell me, ye knowing, and descerning Few,
Where I may find a Friend who's firm & true;
Who dares stand by me, when in deep distress,
And then his Love & Friendship most express;

Who by a secret Sympathy can share
My Joy, my Grief, my Misery, my Care;
He must be prudent, faithful, just & Wise,
Who can, to such a pitch of Friendship, rise.

A Faithful Friend is a strong Defence; and he that hath found such an one,
hath found a Treasure. Nothing doth countervail a Faithful Friend, and his
excellency is unvaluable. A Faithful Friend is the Medicine of Life; and they
that Fear the Lord shall find him. Whoso feareth the Lord shall direct his
Friendship aright; for as he is, so shall his Neighbour (that is his Friend) be also.

W. Rippax, Scrip.ᵗ

1735.

Love and Esteem are the first Principles of Friendship, which always is Imperfect where either of those two is wanting.

No Fate my vow'd Affection shall divide
From thee, Heroick Youth! Be wholly mine!
Take full Possession! All my Soul is thine!
One Faith, one Fame, one Fate shall both attend;
My Life's Companion, & my Bosom-Friend.

Friendship is a strong and habitual Inclination in two Persons to promote the Good and Happiness of one another.

Josephus Champion.
Scrip.

Love first invented Verse, and form'd the Rhyme,

The Motion measur'd, harmoniz'd the Chime.

To lib'ral Arts enlarg'd the Narrow-Soul'd,

Soften'd the fierce, and made the Coward bold.

Anger, in hasty Words or Blows,
It self discharges on our Foes;
And Sorrow too finds some Relief
In Tears, which wait upon our Grief:
So ev'ry Passion, but fond Love,
Unto its own Redress does move.

But that alone the Wretch inclines
To what prevents his own Designs;
Makes him lament, and sigh, and weep,
Disorder'd, tremble, fawn, and creep;
Postures which render him despis'd,
Where he endeavours to be priz'd.

In LOVE what Use of Prudence can there be?

More perfect I, and yet more pow'rful She!

One Look of her's my Resolution breaks;

Reason it self turns Folly when she speaks.

W. Clark Scripsit.

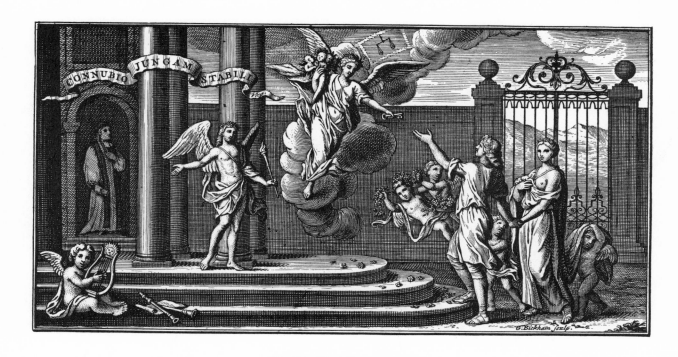

SELECT
Observations on Marriage;
By way of ADVICE.

INTRODUCTION.

Efore Marriage we cannot be too inquisitive and discerning in the Faults of the Person beloved, nor after it too dim-sighted and superficial. However perfect and accomplished the Person appears to you at a distance, you will find many Blemishes and Imperfections in their Humour, upon a more intimate Acquaintance, which you never discovered or perhaps suspected. Here therefore Discretion and Good-nature are to shew their Strength; the first will hinder your Thoughts from dwelling on what is disagreeable, the other will raise in you all the tenderness of Compassion and, Humanity, and by degrees soften those very Imperfections into Beauties.

In Nuptials blest, each loose Desire we shun;
Nor Time can end what Innocence begun.

SAMUEL VAUX,
Scripsit.

No. xv.

Marriage.

Good-Nature, and Evenneſs of Temper,
will give you an easie Companion for Life;
Virtue and good Sense an agreeable Friend;
Love and Constancy, a good Wife or Husband.

Marriage the happiest State of Life would be,
If Hands were only join'd where Hearts agree.

Marriage enlarges the Scene of our Happineſs and Miseries.
A Marriage of Love is pleasant; a Marriage of Interest easie;
and a Marriage where both meet happy. A happy Marriage
has in it all the Pleasures of Friendship, all the Enjoyments
of Sense and Reason, and indeed, all the Sweets of Life.

E. Austin Scripsit.

Marriage.

To set Marriage in its proper Light, we ought to consider it as a State of Grace, and the first Ordinance of God to Mankind; as a Business of the greatest Importance in Life, and a Change of Condition, we cannot make with too much Reverence and Deliberation. Septem.ʳ 1735.

O Marriage! Happiest, easiest, safest State;
Let Debauchees and Drunkards scorn thy Rights,
Who, in their nauseous Draughts & Lusts, profane
Both Thee and Heav'n by whom thou wert ordain'd.

Marriage is describ'd as the State capable of the highest Humane Felicity, as an Institution calculated for a constant Scene of as much Delight as our Being is capable of: It is the Foundation of Community, & the chief band of Society: It is, or ought to be, that State of perfect Friendship, in which there are, according to Pythagoras, Two Bodies with but One Soul. Aama

J. Champion scupt.

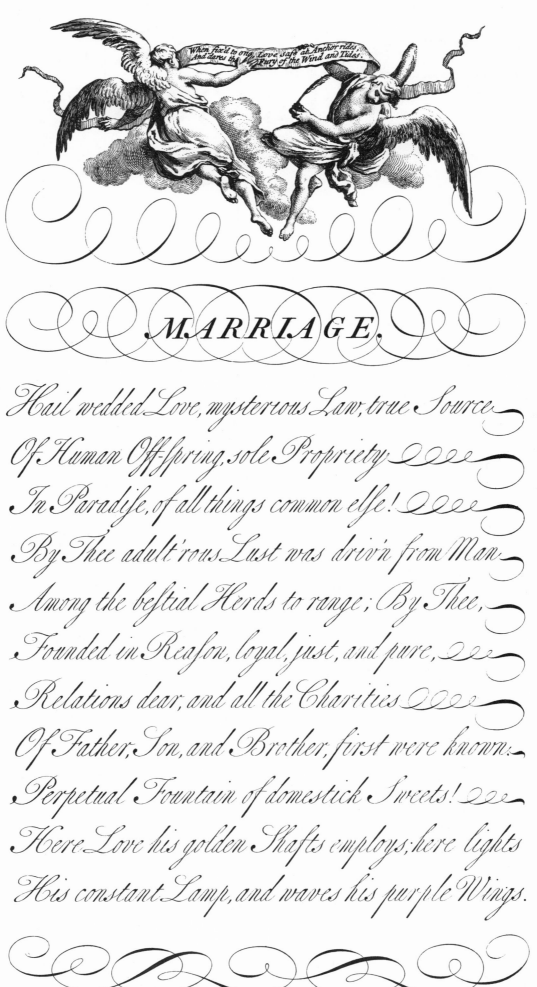

When fix'd to one, Love safe at Anchor rides,
And dares the Fury of the Wind and Tides.

MARRIAGE.

Hail wedded Love, mysterious Law, true Source

Of Human Off-spring, sole Propriety

In Paradise, of all things common else!

By Thee adult'rous Lust was driv'n from Man

Among the bestial Herds to range; By Thee,

Founded in Reason, loyal, just, and pure,

Relations dear, and all the Charities

Of Father, Son, and Brother, first were known.

Perpetual Fountain of domestick Sweets!

Here Love his golden Shafts employs; here lights

His constant Lamp, and waves his purple Wings.

W. CLARK SCRIPSIT,
1735.

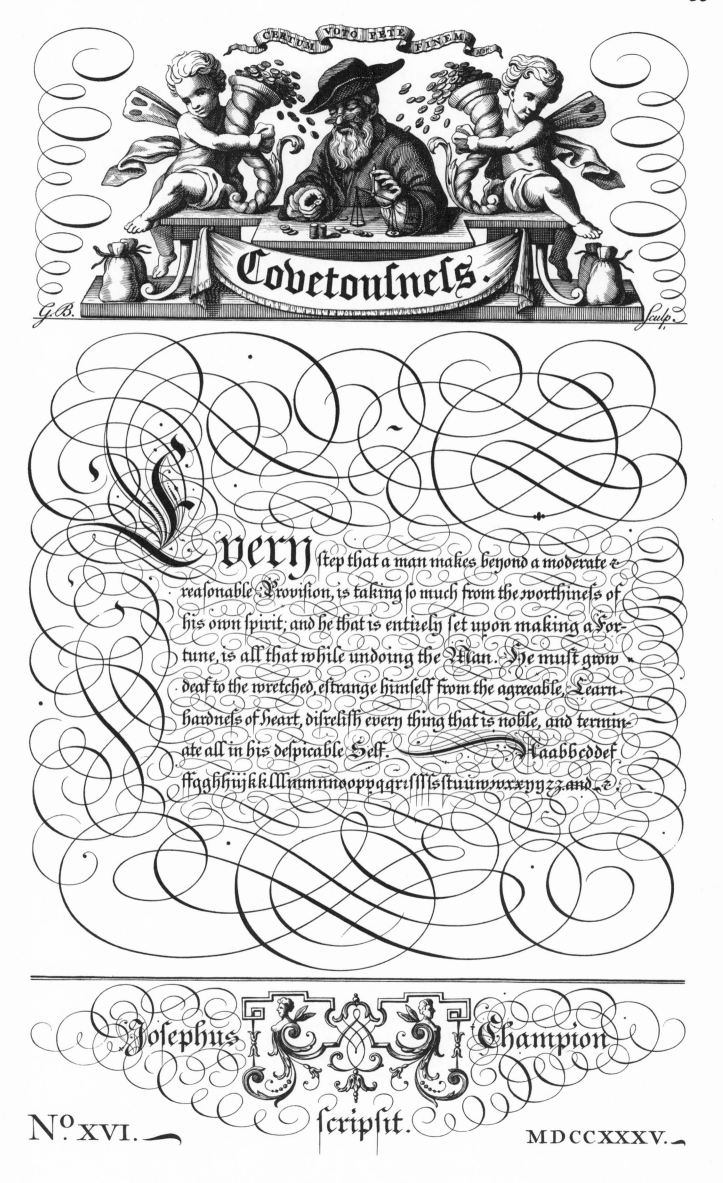

CERTUM VOTO PETE FINEM

Covetousness.

G.B. sculp.

Every step that a man makes beyond a moderate & reasonable Provision, is taking so much from the worthiness of his own spirit; and he that is entirely set upon making a Fortune, is all that while undoing the Man. He must grow deaf to the wretched, estrange himself from the agreeable, Learn hardness of heart, disrelish every thing that is noble, and terminate all in his despicable Self. Aabb ccddef ffgghhiijkk llmmnnooppqqr sssss stuuvwwxxyyzz and &.

Josephus Champion

Nº XVI. scripsit. MDCCXXXV.

To
Zachary Chambers, Esq^r.

Dep.^{ty} Surveyor of his Maj.^{ties} Lands, &c.

ON HIS

Excellent Performances in

Penmanship.

Sir,

In the politest Age we seldom find,
The Man of Business with the Artist join'd;
But in Your Genius both these Talents meet,
To make the happy Character complete.
Thus rightly Form'd; such useful Beauties shine
Thro' all Your Works; what Pen can equal thine?
There flowing Strokes in true Proportion rise;
They charm the Sense, and captivate the Eyes.

Soft, bold, and free, Your Manuscripts still please,
Where all is Masterly, and wrote with Ease;
And ev'ry One, in the next Page, may view
A Curious Specimen, Perform'd by You.
There I, with great Ambition, have Essay'd
My utmost Skill, and all my Art display'd;
Proud if some Fame, with You, I might assume,
By my Engraving Your fine Vive la plume.

Thus, Sir, by copying of Your Works, I aim
To please Mankind, and raise a lasting Name.

George Bickham

Before p. 6.

Before p. 6.

G. Bickham Sculp.

F. Chambers fe.

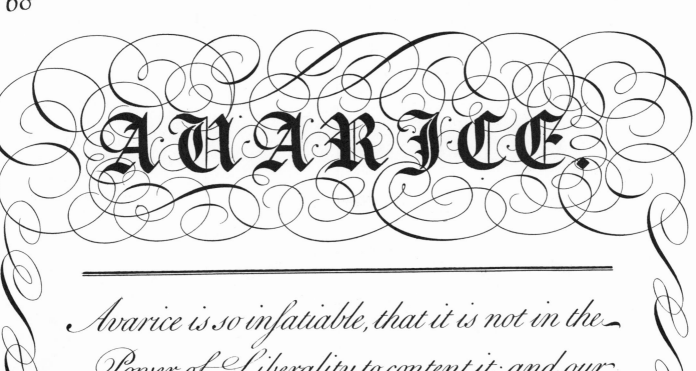

AVARICE.

Avarice is so insatiable, that it is not in the Power of Liberality to content it; and our desires are so boundless, that whatever we get is but in the way to getting more without end.

What Walls can bound, or what compelling Rein
Th' ungovern'd Lust of Avarice restrain?
Wealth he has none, who mourns his scanty Stoie,
And midst of Plenty starves, and thinks he's poor.

So long as we are solicitous for the Increase of Wealth, we lose the true Use of it, and spend our Time in putting out, calling in, and passing our Accounts, without any real and substantial Benefit either to the World, or our selves.

W. Clark Scriplit.

How to get Riches.

Humbly Inscrib'd to the British Nation.

Thro' various Climes, & to each distant Pole,
In happy Tides let active Commerce rowl.
As our high Vessels pass their watry Way,
Let all the Naval World due Homage pay:
Let Britain's Ships export an Annual Fleece,
Richer than Argos brought to ancient Greece;
Returning Loaden with the shining Stores,
Which lye profuse on either India's Shores.

We then shall get great Riches, and y Sway,
To calm the Earth, and vindicate the Sea.
And by your Aid, our Potent Fleets shall go
As far as Winds can bear, or Waters flow;
New Lands to make, new Indies to explore,
In Worlds unknown to plant Britannia's Power,
Nations yet wild by Precept to Reclaim;
And teach 'em Arms, & Arts, in Britain's Name.

Josephus Champion Script

Nᵒ XVII. 1736. G. Bickham sculp.

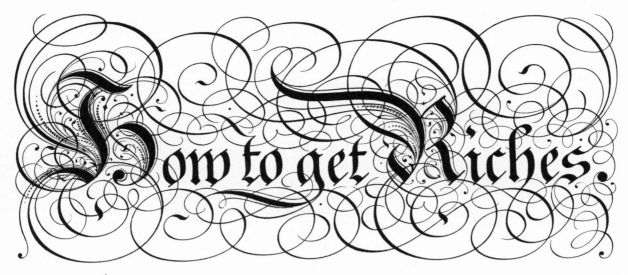

How to get Riches.

The Art of growing Rich consists very much in Thrift: All Men are not equally qualified for getting Money, but it is in the Power of every one alike to practise this Virtue.

Diligence, as well as Thrift is neceſſary for attaining Riches: Both theſe are excellently well recommended to common uſe in the three following

Italian Proverbs;

Never do that by Proxy which you can do your ſelf.
Never defer that 'till To-morrow w.ch you can do To-day.
Never neglect ſmall Matters and Expences.

He who would be before-hand with the World, must be before-hand with his Buſineſs: It is not only ill Management, but discovers a slothful Disposition, to do that in the Afternoon, which should have been done in the Morning.

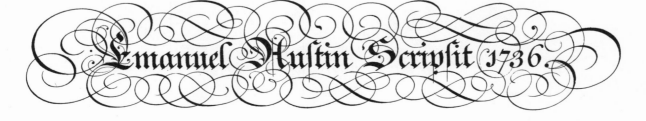

Emanuel Austin Scripſit 1736.

THE

Wisdom of King Solomon in getting

Great Riches

King Solomon made a Navy of Ships on the Shore of the Red Sea, in the Land of Edom. And Hiram sent in the Navy his Servants, Ship-Men that had Knowledge of the Sea, with the Servants of Solomon. And they came to Ophir, and fetch'd from thence Gold, four hundred and twenty Talents, and brought it to King Solomon. Now the Weight of Gold that came to Solomon in one Year, was six hundred threescore and six Talents of Gold; Besides that he had of the Merchant-Men, and of the Traffick of the Spice-Merchants, and of all the Kings of Arabia, and of the Governours of the Country. And all King Solomon's drinking Vessels were of Gold, and all the Vessels of the House of the Forest of Lebanon were of pure Gold, none were of Silver, it was nothing accounted of in the days of Solomon: For the King had at Sea a Navy of Tharshish, with the Navy of Hiram; once in three Years came the Navy of Tharshish, bringing Gold, and Silver, Ivory, and Apes, and Peacocks. So King Solomon exceeded all the Kings of the Earth for Riches, and for Wisdom. I. Kings Chap. IX. Ver. 26, &c.

Be, then, the Naval Stores the Nations Care, New Ships to Build, and batter'd to repair.

W. Clark Scrip.

How

To get Riches.

Useful Attainments in your Minority,
will procure Riches in Maturity; of which
Writing and Accompts, are not the meanest.

Learning, whether Speculative or Practical,
is, in Popular or mixt Governments, the
Natural Source of Wealth, and Honour.

ERUDIT ET DITAT.

William Kippax Scrip.

G. Bickham sculp.

April 15, 1736.

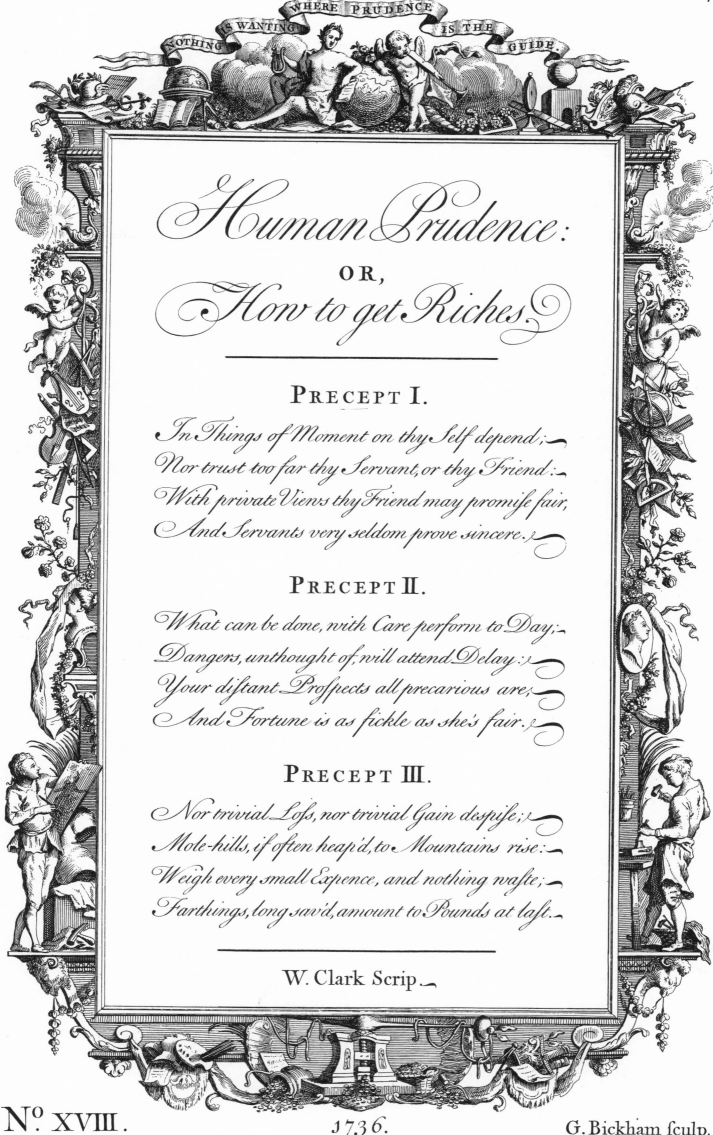

NOTHING'S WANTING WHERE PRUDENCE IS THE GUIDE.

Human Prudence:

OR,

How to get Riches.

PRECEPT I.

In Things of Moment on thy Self depend;
Nor trust too far thy Servant, or thy Friend:
With private Views thy Friend may promise fair,
And Servants very seldom prove sincere.

PRECEPT II.

What can be done, with Care perform to Day;
Dangers, unthought of, will attend Delay:
Your distant Prospects all precarious are,
And Fortune is as fickle as she's fair.

PRECEPT III.

Nor trivial Loss, nor trivial Gain despise;
Mole-hills, if often heap'd, to Mountains rise:
Weigh every small Expence, and nothing waste;
Farthings, long sav'd, amount to Pounds at last.

W. Clark Scrip.

Nᵒ. XVIII.　　　1736.　　　G. Bickham sculp.

Frugality;
Most Commonly Practised
In Old Age.

Old Persons are apt to dread a Missfortune more than others; they have observ'd how Prodigality is punish'd, and Poverty neglected: They are sensible their Strength decays, and their Infirmities increase; and where Labour is impractitable, and Recovery disspaired of, **Parsimony** has not only a better Colour, but is very commendable, and therefore ought to be carefully Practised.

Want is the Scorn of ev'ry wealthy Fool,
And Wit in Rags is turn'd to Riditule.

George Bickham Fecit.

THE
Golden Mean.

Beyond the Golden Mean strive not to go;
His Wants are boundless, whose desires are so.

Happy the Man with Little bless'd,
Of what his Father left, possess'd;
No base Desires corrupt his Head,
No Fears disturb him in his Bed.

Superfl'ous Pomp and Wealth I not desire,
But what Content and Decency require.

Richard Morris Scrip.

Ambition raises a secret Tumult in the Soul,
it inflames the Mind, and puts it into a vio-
lent Hurry of Thought: It is still reaching
after an empty imaginary Good; that has
not in it the Power to abate or satisfy it.

Be not too fond of Honour, Wealth, or Fame,
Since none of these can beautify the Mind;
But may Ambition and your Pride proclaim,
And render you the Jest of Human-kind:
When true Humility, without all these
May make you Happy, & shall make you Please.

Ema.ˡ Austin Scripsit May 18. 1736.

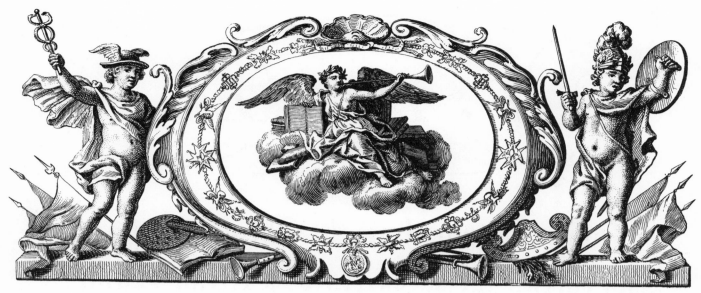

A Poem on Fame:

By Mr. JOHN BANCKS.

Imaginary Good, or true,
Immortal Fame! Thee All persue,
Thee make their End in all they do.

For Thee ye Learn'd their Thoughts impart;
The Bard, his Muse; the Skill'd, his Art:
'Tis Thou that warm'st the Soldier's Heart.

Yet what Thou art, we thus admire,
For which we labour, pant, aspire,
How shall we learn? of whom enquire?

If mere Delusion of the Mind,
Whence are we seriously inclin'd
To court a Shade, a Breath of Wind?

Or if Thou art a real Good,
How can thy Worth be understood,
Thro' Pain, or Poverty persu'd?

Can all the Wreaths that crown his Head,
Compensate now, to Homer dead,
The living Homer's Want of Bread?

Yet who would not a Beggar be,
To grow as much renown'd as He?
Methinks, I wish 'twere offer'd Me!

Thou art, at least, a specious Bait;
And, if Thou wantest aught in Weight,
There's Something sweet in ye Deceit.

HOMER.

N⁰. XIX. G. Bickham Sculpsit. MDCCXXXVI.

F.A.ME.

A scanty Fortune clips the Wings of Fame,
And checks the Progress of a rising Name.

Fame is at best but an inconstant Good;
Vain are the boasted Titles of our Blood.
We soonest Lose what we most highly Prize,
And with our Youth our short-Liv'd Beauty dies.

Fame, due to vast Deserts is kept in Store
Unpaid, till the Deserver is no more.

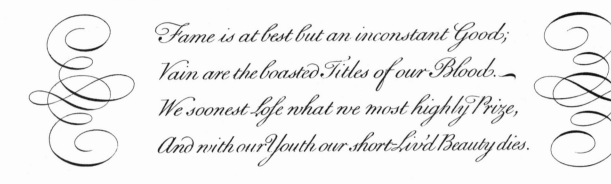

A gen'rous Ardour boils within my Breast,
Eager of Action, Enemy to Rest;
This urges me to fight, and fires my Mind
To leave a memorable Name behind.

The Thing call'd Life, with ease I can disclaim,
And think it over-Sold to purchase Fame.

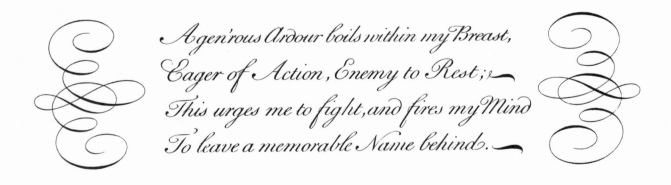

John Bickham Scrip. et Sculp.
1736.

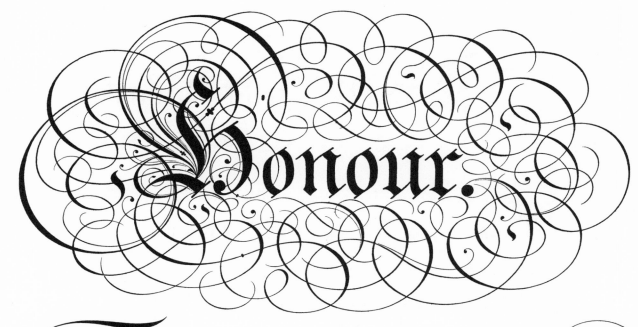

Honour.

The Sense of Honour is of so fine and delicate a nature, that it is only to be met with in minds which are naturally noble, or in such as have been cultivated by great Examples or a refin'd Education. 1736.

W. Clark scrip.

To Mr. John Bland

Sir,

As I am endeavouring to make my Universal Penman as compleat as possible by the Assistance of the best Masters; and as the World is sensible of your peculiar Excellency in Penmanship, this therefore is to renew my Request of an Original from you, which if you please to comply with, as it will be of singular Service to the Publick to have the Works of so correct a Master to Copy after, so it will be Esteem'd a particular Favour confer'd on

August 16, 1736.

Sr. Your most obliged humble Serv.

Geo. Bickham.

Mr. Bickham,

The Academy, Tower Street
20. Augt. 1736.

Agreeable to your Request of the 16.th instant, I shall send You a page as soon as my Leisure from Business will permit, and as I don't doubt but you will perform your Part with the utmost Exactness in the Engraving, So if mine should in any measure prove Serviceable to the Design of your Book, by meeting with a favourable Reception from the Publick, you may rely on further Assistance from,

Sr. Your very humble Servant

Bland.

HONOUR.

On polish'd Springs, true Men of Honour move,
Free is their Service, and unbought their Love:
When Danger calls, and Honour leads the way,
With Joy they follow, and with Pride obey.

Not all the Threats, or Favours of a Crown,
A Prince's Whisper, or a Tyrant's Frown;
Can awe the Spirit, or allure the Mind,
Of him who to strict Honour is inclin'd.

Honour! that Spark of the Celestial Fire,
That above Nature makes Mankind aspire,
Ennobles the rude Passions of our Frame,
With Thirst of Glory and Desire of Fame.

Honour's the Conscience of an Act well done,
Which gives us Pow'r, our own Desire to shun:
The strong and secret Curb of headstrong Will!
The Self-Reward of Good, and Shame of Ill.

O Honour! frail as Life, thy fellow Flow'r,
Cherish'd, and watch'd, and hum'rously esteem'd;
Then worn for short Adornment of an Hour,
And is, when Lost, no more to be redeem'd!

Peter Norman Scrip.

Nº. XX.

G. Bickham sculp.

Honour.

Honour, tho' a different principle from Religion, produces the same effects. The lines of Action, tho' drawn from different parts, terminate in the same point. Religion embraces Virtue, as it is enjoined by the laws of God; Honour, as it is graceful and ornamental to humane Nature.

Honour's a sacred Tie; the Law of Kings,
The noble Mind's distinguishing Perfection,
That aids & strengthens Virtue where it meets her;
And imitates her Actions where she is not.

Bland Script.

HUMILITY.

Humility is the grand Virtue that leads to Contentment; it cuts off the Envy and Malice of Inferiours & Equals, and makes us patiently bear the Insults of Superiours.

As Arrogance, & Conceitedneſs of our own Abilities are very shocking & offensive to Men of Sense and Virtue, we may be sure, they are highly displeasing to that Being who always delights in an humble Mind.

E. Auſtin Scripſit 1736.

Of all the Causes which conspire to blind
Man's erring Judgment & misguide the Mind,
What ÿ weak Head with strongest Biaſs rules
Is Pride, the never-failing Vice of Fools.

Pride hides a Man's faults from
himſelf, and magnifies them to others.

Whatever Nature has in Worth deny'd,
She gives in large recruits of needful Pride;
Pride, where Wit fails, steps in to our defence,
And fills up all the mighty Void of Sense.

George Bickham

FECIT.

Pleasure and Recreation.

Pleasure and Recreation, of one kind or other, are absolutely necessary to relieve our Minds and Bodies from too constant Attention and Labour.

In rural Seats the Soul of Pleasure reigns,
The Life of Beauty fills the rural Scenes;
Ev'n Love, if Fame and Poets truth declare,
Drew first its Breathings in a rural Air.

Recreation after Business is allowable, but he that follows his Pleasure instead of his Business, shall in a little time have no Business to follow.

E. Austin Scripsit December 1736.

No. XXI.

G.B. sculp.

Pleasure.

Too frequent Use does the Delight exclude:
Pleasure's a Toil when constantly pursu'd.

It is a frivolous Pleasure to be the Admiration of a gaping
Croud, but to have the Approbation of a good Man in the
Cool Reflections of his Closet, is a Gratification worthy an
Heroic Spirit: The Applause of the One makes the Head
Giddy; but the Attestation of the other makes ÿ heart glad.

Fond airy Pleasure dances in our Eyes,
And spreads false Images in fair disguise.

W. Clark scrip.

GAMING.

The Diversion of Cards and Dice, however Engaging, are oftner Provocatives to Avarice and Loss of Temper, than mere Recreations and innocent Amusements.

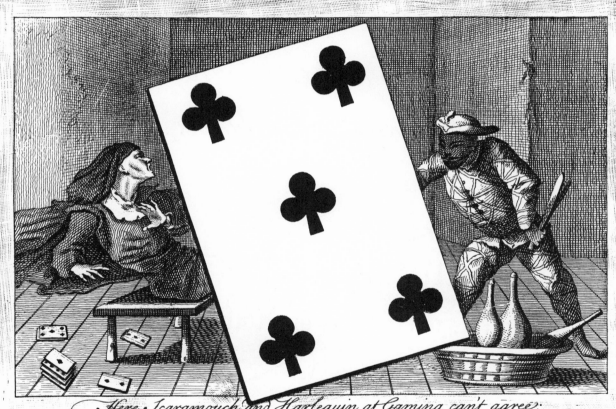

Here Scaramouch and Harlequin, at Gaming can't agree;
They Quarrel, and poor Scaramouch is tumbl'd down you see.

All Cheats at Cards, still gaping for their prey,
Quarrels create; and Mischiefs follow Play:
It loses Time, disturbs y^e Mind and Sense,
Whilst Oaths and Lies are oft the consequence,
And Murders, sometimes, follow loss of Pence.

John Bickham Scrip:

Liberality and *Kindness*, *Generosity* and *Benevolence*: All the Actions that flow from these Springs will fill us with *Pleasure*, and make us Dear to *Heaven* and Acceptable to *Mankind*.

Riches in the Hand of a Beneficent Man are a Blessing to the Publick: Such a one is a Steward to Providence and the noble Means of correcting the Inequalities of Fortune, of relieving the Miserable, and spreading Happiness to all that are within the Reach of his Acquaintance.

William Kippax

Scripsit 1736.

LETTERS.

By the Assistance of Letters the Memory of past Things is preserved, and the Foreknowledge of some Things to come is Revealed: By Them even Things Inanimate Instruct and Admonish Us.

Inscription is the Language of a Tomb;
Art can by Letters speak when Nature's dumb.

Letters annihilate intervenient Time, and make past Ages present; So that the Living and Dead converse together, and w.th this Advantage, that we may learn from the Admonitions of the Dead, that which the Living dare not, or care not to say to Us.

N.º XXII.
Place this N.º
After Page 2.

Geo. Bickham
Fecit.

Round Text Copies;

By Willington Clark,

of Christ-Church Southwark.

Aaaabbccddeefffgghhijkkllmm

nnooppppqrrrsstttuvnnxxyyzzz.

A B C D E F G H I K L M

N O P Q R S T U V W X Y Z.

Authority. Barbarity. Centurions.

Demands. Encomium. Fraternity.

ON Words.

Words are those Channels, by which the Knowledge of Things is convey'd to our Understandings: And therefore upon a right Apprehension of them depends ij Rectitude of our Notions; and in order to form our Judgments right, they must be understood in their proper Meaning, and us'd in their true Sense, either in Writing or Speaking.

In all your Words let Energy be found,
And Learn to rise in Sense and sink in Sound:
Harsh Words, tho' pertinent, uncooth appear;
None please the Fancy, which offend the Ear.

Joseph Champion Scripsit.

COPIES.

Aim at improvement in every line.

Business makes a Man respected.

Commendation animates the mind.

Diligence in youth is commendable.

Excess produceth great prodigality.

Friendship improves Happiness.

W. Clark — Scripsit.

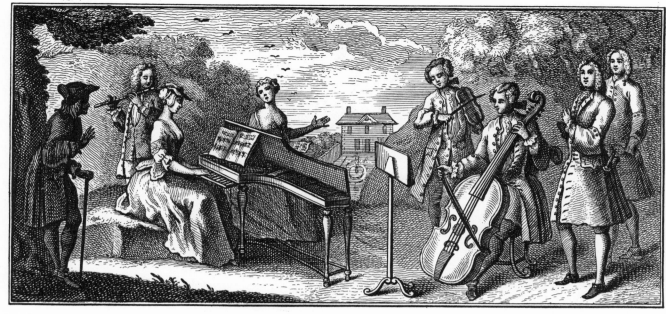

Musick.

Musick is an insearchable and excellent Art, which rejoiceth the Spirits and unloadeth Grief from the heart, and consisteth in time and number.

Musick alone with sudden Charms can bind
The wand'ring sense, & calm the troubled mind.

W. Clark Script. G. Bickham Sculp.

Musick.

Hear how Timotheus' various Lays surprize;
And bid alternate passions Fall and rise;
While, at each Change, the Son of Lybian Jove,
Now burns with Glory, and then melts with Love,
Now his fierce Eyes with sparkling Fury glow,
Now Sighs steal out, and Tears begin to Flow:
Persians and Greeks like Turns of Nature found,
And the World's Victor stood subdu'd by Sound.

Tell me, O Muse! (for thou, or none, can'st tell)
The mystick pow'rs that in soft Numbers dwell.
At first a various unform'd hint we Find,
Rise in some Godlike Poet's fertile Mind,
Till all the Parts and Words their Places take;
And with just Marches, Verse & Musick make.

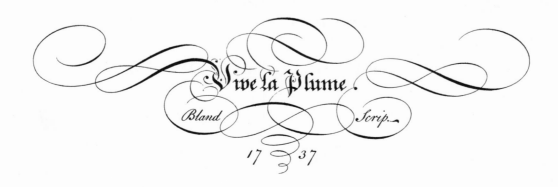

Vive la Plume.

Bland Scrip.

17 37

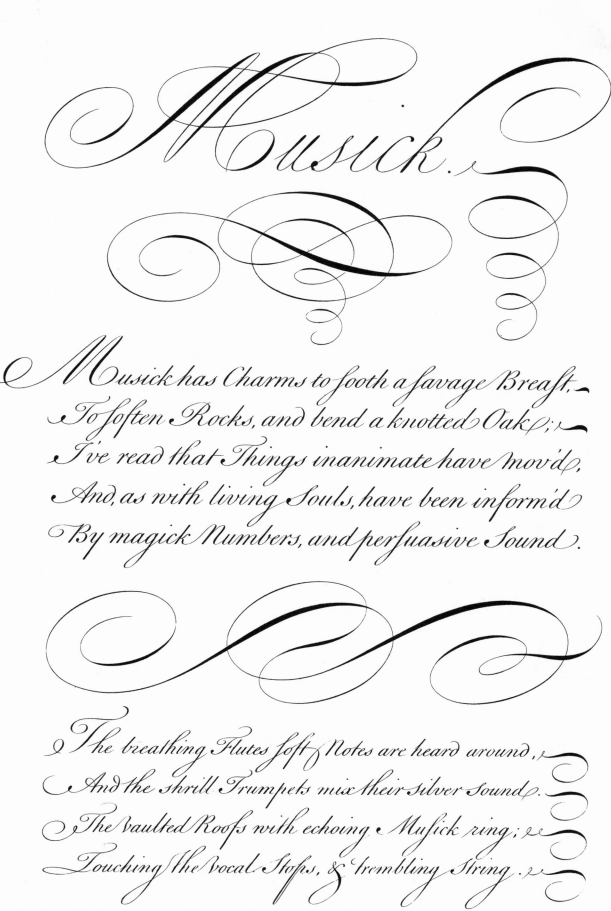

Musick.

Musick has Charms to sooth a savage Breast,
To soften Rocks, and bend a knotted Oak;
I've read that Things inanimate have mov'd,
And, as with living Souls, have been inform'd
By magick Numbers, and persuasive Sound.

The breathing Flutes soft Notes are heard around,
And the shrill Trumpets mix their silver Sound.
The vaulted Roofs with echoing Musick ring;
Touching the vocal Stops, & trembling String.

Brooks,
Scr.

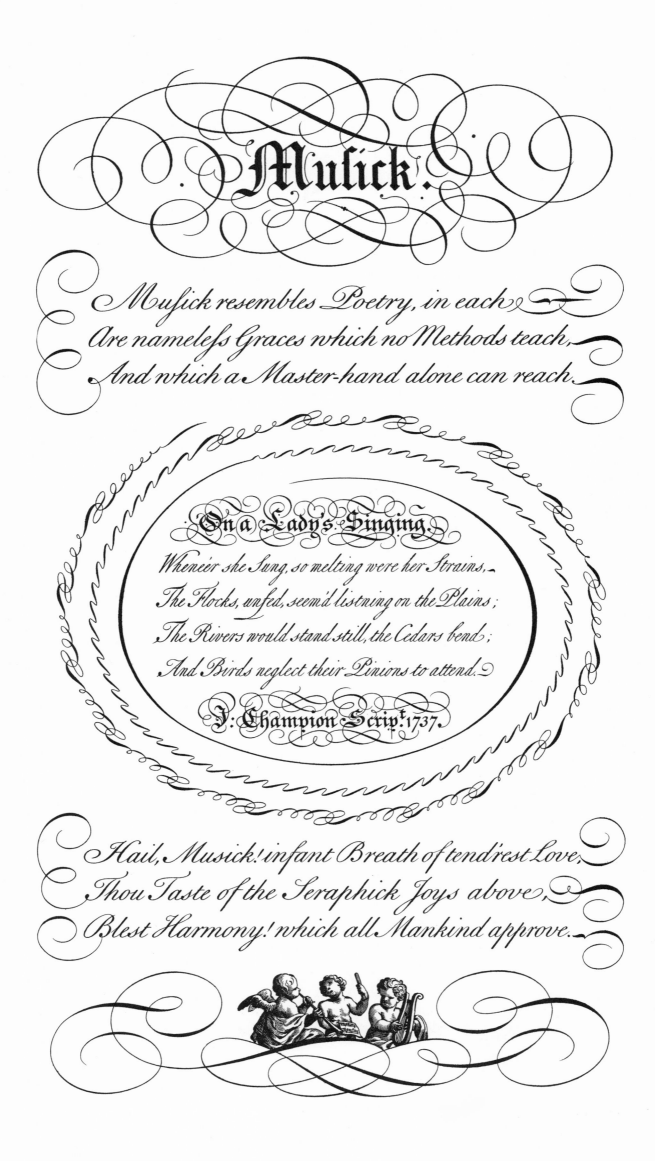

Musick.

Musick resembles Poetry, in each
Are nameless Graces which no Methods teach,
And which a Master-hand alone can reach.

On a Lady's Singing.

Whene'er she Sung, so melting were her Strains,
The Flocks, unfed, seem'd list'ning on the Plains;
The Rivers would stand still, the Cedars bend;
And Birds neglect their Pinions to attend.

J: Champion Script. 1737.

Hail, Musick! infant Breath of tend'rest Love,
Thou Taste of the Seraphick Joys above,
Blest Harmony! which all Mankind approve.

Poetry.

True Poetry carries its own Conviction along with it, and has native Beauty enough to silence all its Opposers, and dazzle them with over-powering Lustre. Like Insects at Night, it spreads a Circle of Day around it, and undesignedly betrays its own Beauty.

Nathaniel Dove Scripsit

Nº XXIV.

G.B. Sculpᵗ

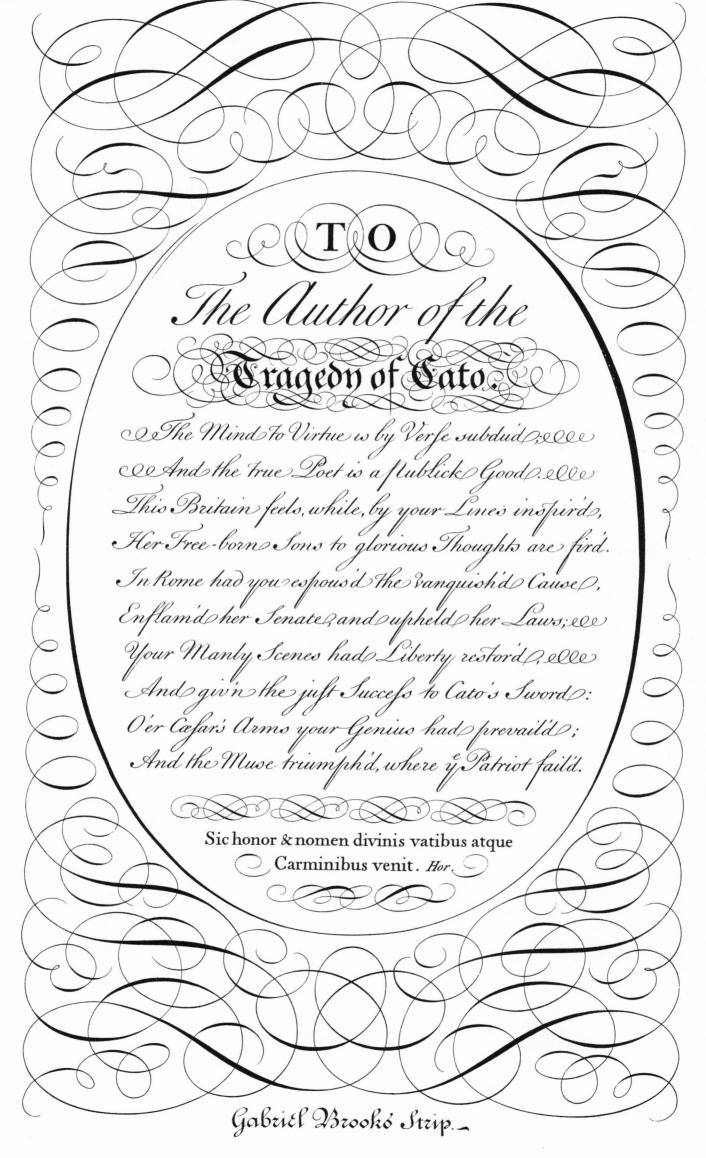

TO
The Author of the
Tragedy of Cato.

The Mind to Virtue is by Verse subdu'd;
And the true Poet is a Publick Good.
This Britain feels, while, by your Lines inspir'd,
Her Free-born Sons to glorious Thoughts are fir'd.
In Rome had you espous'd the vanquish'd Cause,
Enflam'd her Senate, and upheld her Laws;
Your Manly Scenes had Liberty restor'd,
And giv'n the just Success to Cato's Sword:
O'er Cæsar's Arms your Genius had prevail'd;
And the Muse triumph'd, where ye Patriot fail'd.

Sic honor & nomen divinis vatibus atque
Carminibus venit. *Hor.*

Gabriel Brooke Strip.

Poetry has had the general Suffrage of all Ages on its side, and been admir'd even by Barbarians themselves, when all other Traces of Politeness have been effaced.

Thou know'st Parnassus Sweets the World invite,
And smoothest Strains gives always most delight;
When Truths sublime in Verse harmonious roll,
'Twill into Raptures raise a Stoick Soul.

Joseph Champion Scripsit.

Poetry

Poetick Flights are pleasing Charms we use,
Heroick Thoughts, and Virtue to infuse.

Poetry is an Art, whose sweet
Insinuation might almost convey
Piety into resisting Nature, and melt
the hardiest Soul to the love of Virtue.

Things of deep Sense we may in Prose unfold,
But they please best in lofty Numbers told.

E. Austin Scr.

Painting.

Of all the Productions of human Ingenuity, of all the
Operations, which the Fancy, assisted by the Hand is
capable, there is none more excellent or Useful, none
more Universally Admired than the Art of Painting.

Whatever yet in Poetry held True,
If duely weigh'd, holds just in Painting too;
Alike from Heav'n congenial first they came;
The same their Labours, & their Praise y̆ same.
Alike, by turns, they touch the conscious Heart,
And Each on Each reflects the Lights of Art.

It is not without just Ground that the Art of Painting
is held in such high Repute: Her Beauties are, & ever
will be Entertaining to the Curious, and Nothing more
illustrates the Glory of a Nation than her Productions.

Champion Scripsit.

Like Zeuxis first with trembling Hand design
Some humble Work, and study Line by Line;
A Roman Urn, a Grove-encircl'd Bow'r,
The blushing Cherry, or the bending Flow'r.
Painful and slow to Noble Arts we rise,
And long long Labours wait the glorious Prize.
Yet by Degrees your steadier Hand shall give
A bolder Grace, and bid each Object live,
Ev'n Raphael's self from rude Essays began,
And shadow'd with a Coal his shapeless Man.

Bland.

Scrip.

Painting.

In Ancient Times, when Painting first began,
A Pen, or Chalk, thus imitated Man.

Long time the Sister-Arts, in Iron Sleep,
A heavy Sabbath did Supinely keep :
At length, in Raphael's Age at once they rise,
Stretch all their Limbs, & open all their Eyes.
Thence rose the Roman & the Lombard Line,
One Colour'd best, and one did best Design.
Raphael's, like Homer's, was the nobler Part;
But Titian's Painting look'd like Virgil's Art.

By slow Degrees the Painting Art advanc'd,
As Man grew polish'd, Picture was inhanc'd.

Brooks. Scr.

Decorum in Painting.

'Twas a Saying of Xenophon, that, Nothing pleases a Man so much as Decency & Order: And 'tis a Rule in Horace, which is equally Just in Painting as in Poetry.

Set all things in their own peculiar place,
And know, that Order is the greatest grace.

This good Oeconomy, or distribution of Figures and Strokes in their proper places, produces the same Effect, in relation to the Eyes, as a Concert of Musick to the Ears.

Nath.ˡ Dove — Scripsit.

ON
SCULPTURE.

Sculpture, too Sacred to be Man's Device,
When Moses govern'd, had in Heaven its Rise;
Where GOD, to make the useful Mist'ry known,
He Carv'd his Laws on Tabulets of Stone;
And thus, at once, to Israel did impart
His own Commands, and this immortal Art.

G. Brooks *Scripsit.*

17 37.

Nº XXVI. G: B: Sculp.

Sculpture.

Some carve y^e Trunks, & breathing Shapes bestow,
Giving the Trees more Life than when they grow.

The Ancients are of Opinion that the Labours of the Sculptor would have done greater Service to their Deities, than those of the Poet. They tell us that the great Veneration which the People paid to them, was owing to their Statues, and these were of Use to improve the Wonders the Poets related of those Gods. The Statue of Jupiter Olympus made them more easily give Credit to the Fable, that arms him with Thunder-bolt.

The Statues, so well Carv'd, such Life did show,
Spectators wonder'd why they did not go.

W. Clark Scrip.

THE

Grecian Carver.

Wise Phidias, thus his Skill to prove,
Thro' many a God advanc'd to Jove;
And taught the polisht Rocks to shine
With Airs and Lineaments Divine;
Till Greece, amaz'd, and half-afraid,
Th' Assembled Deities survey'd.

This Wonder of the Sculptor's Hand
Produc'd, his Art was at a Stand:
For who wou'd hope New Fame to raise,
Or risque his well-establish'd Praise,
That, his high Genius to approve,
Had carv'd the Gods, and came to Jove.

He Carv'd in Iv'ry such a Maid, so Fair,
As Nature could not with his Art compare.

J. Champion scripsit.

Sculpture

Whoever Meditates some great Design,
Let Strength and Nature dawn in every Line;
Let Art and Fancy full Perfection give,
And Each bold Figure seem to move and live.

The meanest Sculptor in the Æmilian Square,
Can imitate, in Brass, the Nails and Hair;
Expert in Trifles, and a cunning Fool,
Able t'express y Parts, but not dispose y Whole.

Says Horace

In his Art of Poetry.

Liberty.

The Love of Liberty with Life is giv'n,
And Life it self's th'inferior gift of Heav'n.

Lucius seems fond of Life; but what is Life?
'Tis not to stalk about, and draw fresh Air
From time to time, or gaze upon the Sun;
'Tis to be Free. When Liberty is gone,
Life grows insipid, and has lost its Relish.

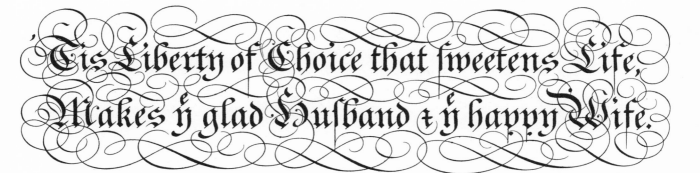

'Tis Liberty of Choice that sweetens Life,
Makes y̆ glad Husband & y̆ happy Wife.

W Clark Scr

Nº. XXVII.

G. B. fculp.

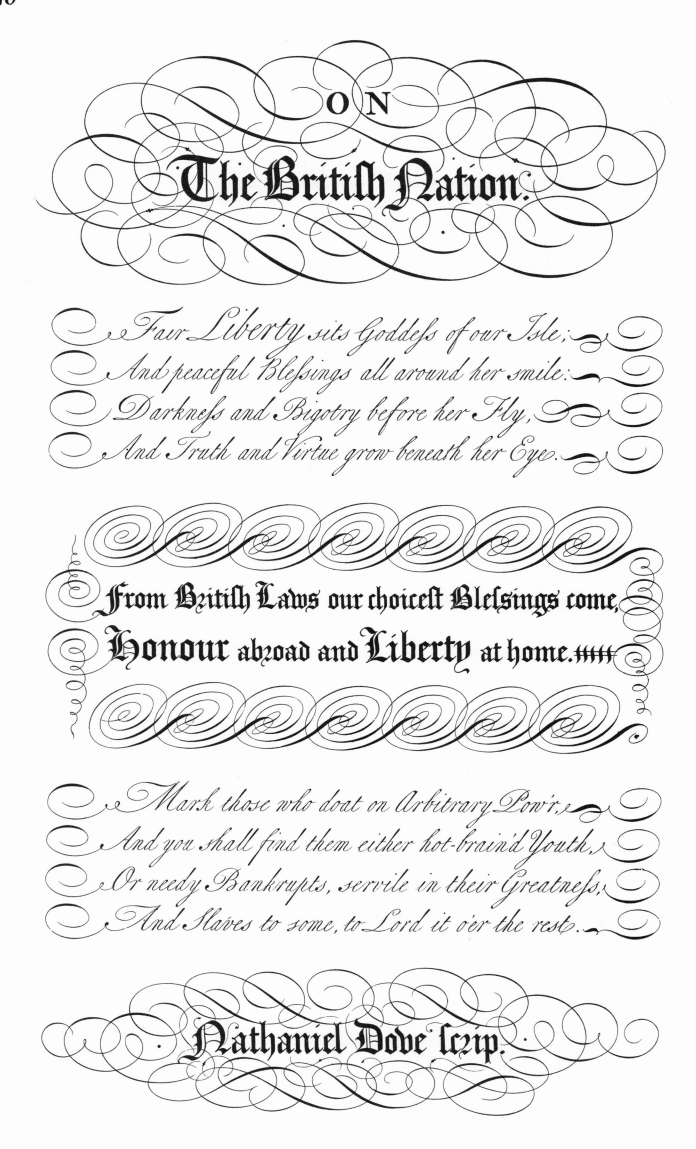

ON
The British Nation.

Fair Liberty sits Goddess of our Isle,
And peaceful Blessings all around her smile:
Darkness and Bigotry before her Fly,
And Truth and Virtue grow beneath her Eye.

From British Laws our choicest Blessings come,
Honour abroad and Liberty at home.

Mark those who doat on Arbitrary Pow'r,
And you shall find them either hot-brain'd Youth,
Or needy Bankrupts, servile in their Greatness,
And Slaves to some, to Lord it o'er the rest.

Nathaniel Dove scrip.

LIBERTY

O Liberty! thou Goddess heav'nly-bright;
Profuse of Bliss, & pregnant with Delight!
Eternal Pleasures in thy Presence reign,
And smiling Plenty leads thy wanton Train.
Eas'd of her Load, Subjection grows more light,
And Poverty looks chearful in thy Sight:
Thou mak'st the gloomy Face of Nature gay,
Giv'st Beauty to the Sun, & Pleasure to the day.

J. Champion Scripsit.

Liberty.

LIBERTY SHOULD REACH EVERY INDIVIDUAL OF A PEOPLE, AS THEY ALL SHARE ONE COMMON NATURE; IF IT ONLY SPREADS AMONG PARTICULAR BRANCHES, THERE HAD BETTER BE NONE AT ALL; SINCE SUCH A LIBERTY ONLY AGGRAVATES THE MISFORTUNE OF THOSE WHO ARE DEPRIV'D OF IT, BY SETTING BEFORE THEM A DISAGREEABLE SUBJECT OF COMPARISON.

Brooks Scr.

VARIOUS Forms of Business, *Relating to* Merchandize, and Trade.

VIZ.

Bills of Parcels, Book-Debts, Promissory Notes, Acquittances, Bills of Exchange (Inland and Foreign) Bills of Entry, Commissions, Directions, and Restrictions; Invoices, Accounts of Sale, Accounts Current, Letters on several Occasions, Petitions, Oriental Languages, &c.

Design'd

For the Improvement of Youth, in all the Useful Branches of Penmanship;

And Interspers'd with

Instructive and Entertaining Topics, for the Amusement of the Curious:

Being,

The Second Part of the Universal Penman,

Written by several Eminent Masters.

Nil Penna sed Usus.

Nº XXVIII.

G. Bickham Fecit.

To

The Merchants, and Tradesmen of Great-Britain.

Gentlemen, ————————————

> By the generous Encouragement You have been pleas'd to allow Our Eminent Penmen; Writing and Accounts, no Lefs than Trade & Commerce, are become the Glory of Great-Britain. And as, by Your extensive Trading, and frequent Use of the Pen, You have increas'd the Wealth of each particular City, and made this Island distinguish'd and honour'd in all the known Parts of the World; therefore I thought You Gentlemen, the best Judges & Patrons of this Part of the Universal Penman; which Consists chiefly of Various Forms of Bufinefs, defign'd for the Improvement of Youth under Your Care: And hoping this Freedom may be excus'd, I beg Leave to Subfcribe my Self, ————————————

Gentlemen,

Your most obedient, and very humble Servant

London 19 May 1738.

G. Bickham

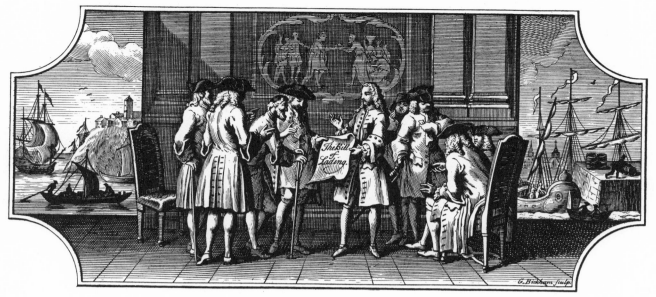

Commerce.

Trade and a well regulated Commerce flourishes by
Multitudes, and gives Employment to all its Professors:
Fleets of Merchant-men are so many Squadrons of
Floating Shops, that vend our Wares & Manufactures
in all the Markets of the World, and, with Dangerous
Industry, find out Chapmen under both the Tropicks.

Josephus

Thou, pregnant Commerce! art ÿ source of Peace,
Parent of Arts, and Parent of Increase;
By thy diffusive Stores all Nations smile,
Thou art to every Clime a Second Nile.

Champion

Scripsit.

Bills of Parcels.

The Hon.ble the Lady Ashly

Bought of Simon Pindar.

1738. March 29.

		£ : s : d	£ : s : d
36. China Plates	at _ : 3 : 8 each	£ 6 : 12 : _	
18. Dishes Ditto	at _ : 10 : 6 D.o	9 : 9 : _	
A Tea Table Set compleat		3 : 18 : 4	
Indian Sprig'd Muslin 1 pes q.t 14 Yards	at _ : 9 : p Y.d	6 : 6 : _	
Fine Chints 6 pieces	at 3 : 3 : 6 p p.s	19 : 1 : _	
30 Indian Fans	at _ : 2 : 6 each	3 : 15 : _	
		£. 49 : 1 : 4	

M.r David Chambers

Bought of James Holt.

1738.

April, 19.

		£ : s : d	£ : s : d
15 Pair of Womens Worsted Hose mixt	at 5 : 7 . p Pair	£ 4 : 3 : 9	
23 Ditto of Mens Silk	at 14 : _ D.o	16 : 2 : _	
32 Ditto of Mens Yarn	at 3 : 2 D.o	5 : 1 : 4	
18 Ditto of Norwich Hose	at 4 : 10 D.o	4 : 7 : _	
40 Ditto of Thread	at 3 : 6 D.o	7 : _ : _	
26 Ditto of Womens Silk Gloves	at 4 : 8 D.o	6 : 1 : 4	
		£. 42 : 15 : 5	

N Dove scr.

Commerce.

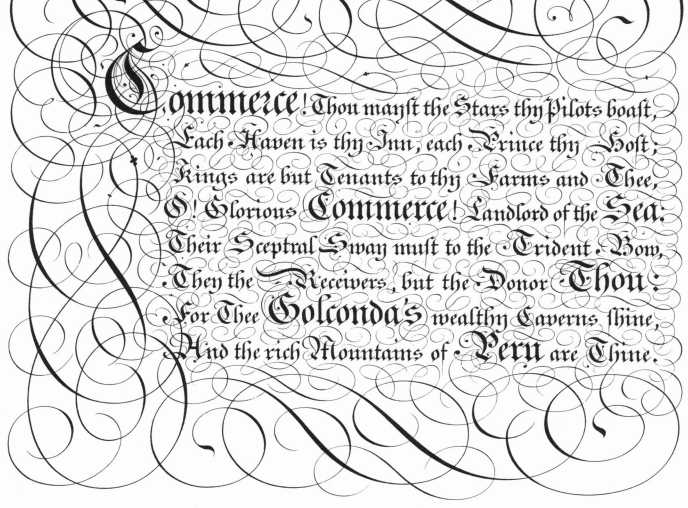

Commerce! Thou mayst the Stars thy Pilots boast,
Each Haven is thy Inn, each Prince thy Host;
Kings are but Tenants to thy Farms and Thee,
O! Glorious Commerce! Landlord of the Sea:
Their Sceptral Sway must to the Trident Bow,
They the Receivers, but the Donor Thou;
For Thee Golconda's wealthy Caverns shine,
And the rich Mountains of Peru are Thine.

N. Dove

Scripsit.

N.º XXIX. 17 38. G.B. sculp.

Book-Debts.

The Rt Honourable the Lord Spires Dr

1738.　　　　　To Thomas Noise Upholder. ——

April 5, A Rich Crimson Damask Bed laced Compleat.........	£75 . 15 . _
6, A Set of Window Curtains, & Vallens Ditto	16 . 11 . 8
May 7, Chairs 10, with 2 Armd Do Walnut Tree fram'd	34 . 12 . 6
9, A fine Carpet, Counterpane, and an Otterdown Quilt	12 . 10 . _
June 6, A Crimson Velvet Easy Chair, & 2 Stools ditto.............	13 . 7 . 6
13, A Wrought Bed dimitty and Furniture Compleat.... 28 . 18 . 4	
	£181 . 15 . _

Her Grace the Dutchess of Ogdinia Dr

1738.　　　　　To Samuel Acres Cabinet maker.

Octor 3, A Chimney Glass, and a pair of Sconces..............	£ 5 . 18 . _
4, A Pair of Peer Glasses 72 Inches, in Guilt frames..........	30 . _ . 9
10, A Pair of Indian Cabinets..... at £43. 10 each, is	87 . _ . _
12, A Fine Indian four leav'd Screen, & a Fire Screen	17 . 10 . _
Nov. 18, A Book Case wth Glass doors, & Corner Cupboard do...	21 . _ . 1
21, A Walnut tree Table, & a Set of dressing boxes Japand....	3 . 4 . _
	£164 . 12 . 10

Joseph Champion Script

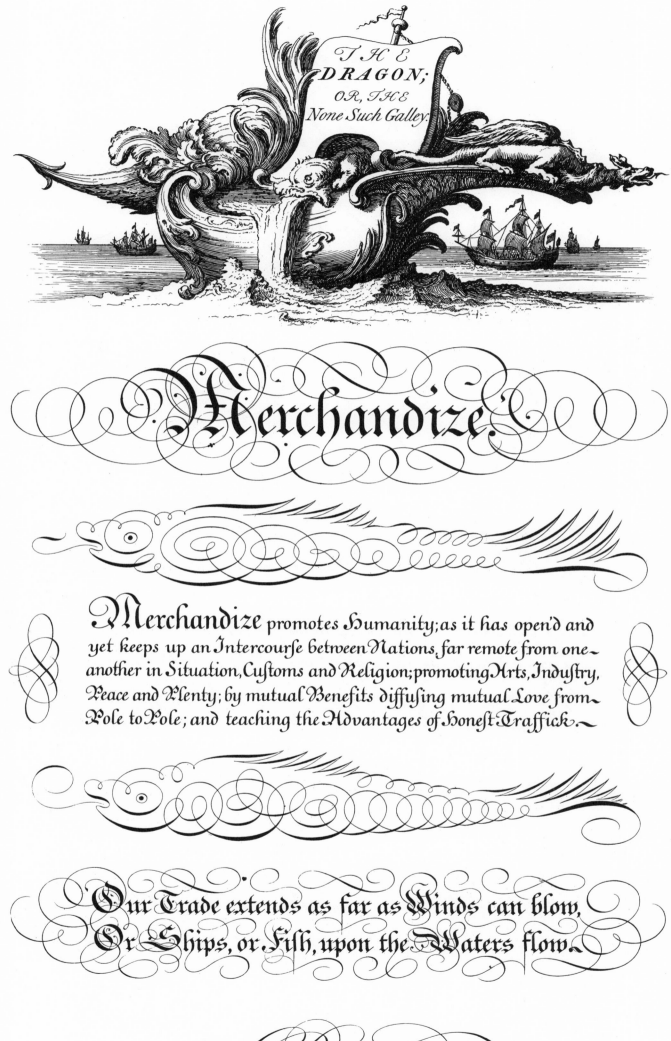

THE
DRAGON;
OR, THE
None Such Galley.

Merchandize.

Merchandize promotes Humanity; as it has open'd and
yet keeps up an Intercourse between Nations, far remote from one
another in Situation, Customs and Religion; promoting Arts, Industry,
Peace and Plenty; by mutual Benefits diffusing mutual Love from
Pole to Pole; and teaching the Advantages of Honest Traffick.

Our Trade extends as far as Winds can blow,
Or Ships, or Fish, upon the Waters flow.

G. Bickham
Sculps.t

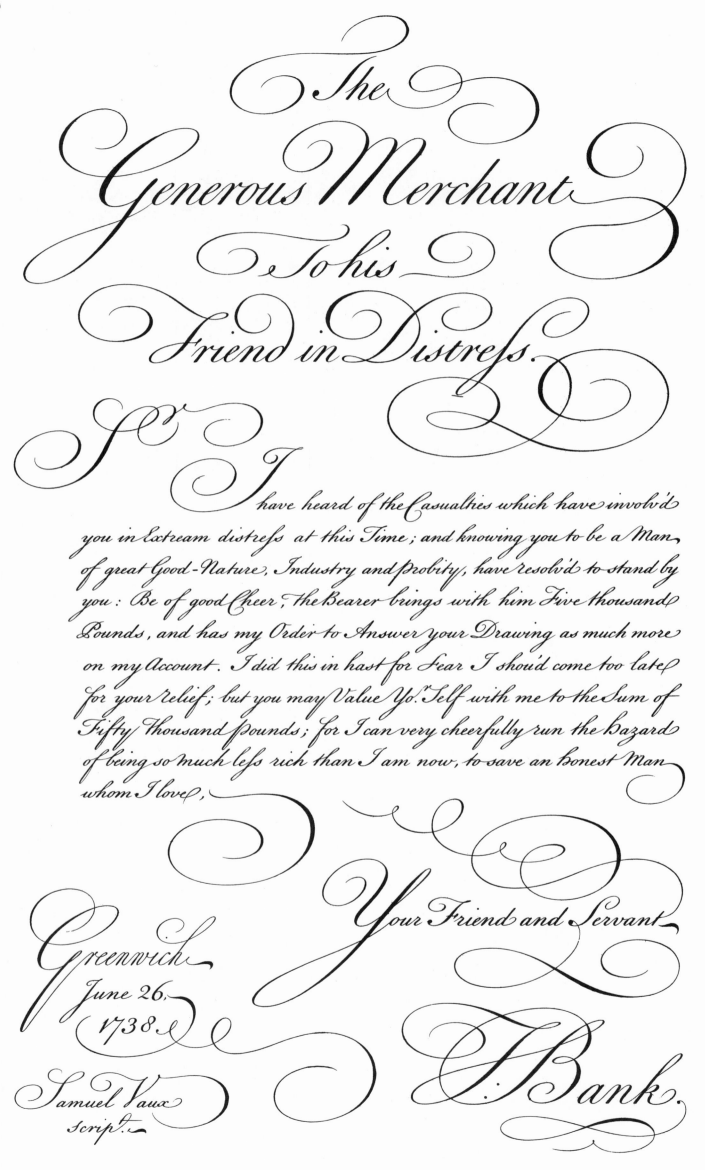

The Generous Merchant To his Friend in Distress.

Sr

I have heard of the Casualties which have involv'd you in Extream distress at this Time; and knowing you to be a Man of great Good-Nature, Industry and Probity, have resolv'd to stand by you: Be of good Cheer, the Bearer brings with him Five thousand Pounds, and has my Order to Answer your Drawing as much more on my Account. I did this in hast for Fear I shou'd come too late for your Relief; but you may Value Yor Self with me to the Sum of Fifty thousand Pounds; for I can very cheerfully run the hazard of being so much less rich than I am now, to save an honest Man whom I love,

Your Friend and Servant

Greenwich.
June 26.
1738.

Samuel Vaux
script.

T. Bank.

THE
Honest Merchant;
OR,
Thorowgood to Trueman.

Honest Merchants, as such, may sometimes contribute to the Safety of their Country; as they do at all times to its Happiness; therefore if you should be tempted to any Action that has the appearance of Vice or Meanness in it, on reflecting upon the Dignity of our Profession, you may, with honest Scorn, reject whatever is unworthy of it. And as the Name of Merchant never degrades the Gentleman, so by no means does it exclude him from that Denomination, only take heed not to purchase the Character of Complaisant at y̆ Expence of yo.r Sincerity.

Merchants for Traffick form Designs,
And give to Britain Indian Mines.

A Bricklayer's Bill.

S.ʳ Pargiter Fleetwood, D.ʳ

To James Mainstone for Work & Materials
in his House on Tower-hill, London.

1738.				
Mar. 28. Bricks	25 thous.ᵈ	at 15:7 ⅌ M.	£	19 . 9 . 7
30. Tiles	11 Ditto.	at 19:5 Ditto.		10 . 13 . 7
Apr, 5. Lime	28 hund.	at 15:11 ⅌ hund		22 . 5 . 8
12. Sand	19 Load.	at 3:10 ⅌ Load		3 . 12 . 10
May, 7. Ridge Tiles	149	at 8: 1 ⅌ hund		— . 12 . —
June, 16. Work, for Self	90 Days,	at 3:— ⅌ diem		13 . 10 . —
—. D.ᵒ y Labourer.	90 D.ᵒ	at 1:8 Ditto.		7 . 10 . —
—. D.ᵒ my Man.	90 D.ᵒ	at 2:6 Ditto.		11 . 5 . —
			£	88 . 18 . 8

N.B. A Brick ought to be 9 Inches long, 4¼ broad, & 2½ thick. 500 Bricks are a load, a thousand Tiles the same. 25 Bushels are a hundred of Lime. About 4500 Bricks will make a Rod of Brickwork, Viz. 272¼ Square Feet, a Brick & a half thick.

J. Champion Scripsit.

DOMINE DIRIGE NOS.

CREDIT.

The Merit of the Merchant is above that of all other Subjects; For while he is untouched in his Credit, his Hand-writing is a more portable Coin for the Service of his Fellow Citizens, & his Word the Gold of Ophir to the Country wherein he resides.

The most unhappy of all Men, and the most exposed to the malignity or Wantonness of the common Voice, is the Trader. Credit is undone in Whispers. The Tradesman's Wound is received from one who is more private & more cruel than the Ruffian with the Lanthorn and Dagger.

Brooks.

Sir Andrew Gold and Co.

Bought of the United East-India Co.
At Four Months, 27.ᵗʰ Novemᵣ. 1738.

Pepper, 2 Lots viz

		Ꝑ	qᵣ ℔	℔
Nº 17.... 10 Baggs of...	27 : 1 : 18.	Tr.	150.	
20.... 10 Ditto........	24 : 3 : 24		138.	
Gr... 52 : 1 : 14			288.	
Tr...... 2 : 2 : 8.				
Nt.. 49 : 3 : 6... at 10½ Ꝑ ℔... £ 244 : — : 9				

Red-wood, 2 Lots viz

		Ton Ꝑ
Nº 47.... 120 Sticks......	10 : 13.	
48.... 100 Ditto.....	11 : 12.	
220 Sticks...... 22 : 5.. at 3 : 7. Ꝑ Ton... £ 74 : 10 : 9		

Wormseed, 3 Bales, viz

		Ꝑ Ꝑ qᵣ ℔
Nº 18... w......	3 : 1 : 10.	
24... dº....	4 : 2 : — .	
27... dº......	2 : 3 : 19.	
Gr.. 10 : 3 : 1.		
Tr... 1 : — : 15.		
Nt.. 9 : 2 : 14... at 13½ Ꝑ ℔........ £ 60 : 12 : 9		

£ 379 : 4 : 3

Nathaniel Dove, Scripᵗ

LABOUR.

Love Labour; if you do not want it for Food, you may
for Physick: It strengthens the Body, invigorates the
Mind, and prevents the fatal Consequences of Idleness.

In the sweat of thy Face shalt thou eat Bread, until thou
return unto the Ground; for out of it wast thou taken; for
Dust thou art; and unto Dust shalt thou return. Gen. 3. 19.

E. Austin Scripsit.

Nᵒ. XXXI. 1738. G.B. Sculp.

A Carpenter's Bill.

Conrade Dubois Esq. Dr

To Henry Sims, For Work & Materials
in his House at Henley Park, Surrey.

1738.

				£	s	d		£	s	d
May 18,	Oaken Timber	12 Load	at	2	5	—	a Ton	£ 33	15	—
do 27,	Fir Timber	35 Ton	at	1	12	10	a Load	45	19	4
June 11,	Oaken Plank	96 Foot	at	—	—	3½	⌽ Foot	1	8	—
do 15,	Norway Deals	590	at	6	15	—	⌽ hund	33	3	9
do 29,	Sixpenny Nails	29 Thousd	at	—	3	10	⌽ M	5	11	2
—,	Tengroat Nails	30 Do	at	—	14	10	Do	22	5	—
July 16,	Work for myself	90 Days	at	—	3	4	⌽ day	15	—	—
—,	Do For 1 Man	90 do	at	—	2	6	do	11	5	—
—,	Wainscot	73 Yds	at	—	3	2	⌽ Yd agreed	11	11	2
—,	Double Quarter	58 Feet	at	—	—	4	⌽ Foot	—	19	4
							£	180	17	9

Note, Deals and Nails are 120 to the Hundred, 50 Feet
are a Load, and 40 Feet a Ton of Timber.

N: Dove scr.

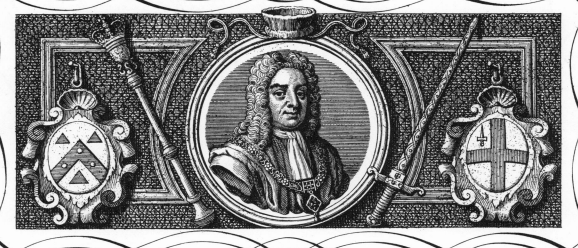

A Lord Mayor of LONDON.

Reputation.

Reputation, Honour, and Preferm.ᵗ are gain'd,
retain'd, and maintain'd by Discretion, Sinceri-
ty, and Humility; with which till a Man is ac-
commodated and accomplish'd, he is not esteem-
ed as a worthy Member in a Common-wealth.

*Reputation, which is the Portion of every Man
who would live with the knowing and elegant Part of
Mankind, is as stable as Glory if it be as well founded; & yᵉ
common Cause of human Society is thought to be concern'd
when we hear a Man of good Behaviour calumniated.*

Moˢ. Gratwick, Scripsit.

East India House, 25 Septem.^r 1738.

Sir Anthony Dealmuch,

Bought of the United East-India Comp.^a

At a publick Sale, 2 Lots of Callico, and 2 Lots of Muslin, on a Discount of £6 P. Cent.

Contents viz

Lot, 20, Containing 150 Pieces Callico of the Wager
At £7 . 18 . 6 P. Piece............ £ 1188 . 15 . —

Lot, 54, Containing 150 Pieces D.º of the Berwick
At £8 . 15 . 6 P. Piece............ £ 1316 . 5 . —

Lot, 95, Containing 150 Pieces Muslin of the Bolton
At £10 . 11 . 7 P. Piece............ £ 1586 . 17 . 6

Lot, 109, Containing 150 Pieces D.º Strip'd of the Nassau
At £13 . 17 . 4 P. Piece............ £ 2080 . — . —

£ 6171 . 17 . 6

The 29 Septemb.^r 1738.

Charles Simonds, Broker

Dove Script.

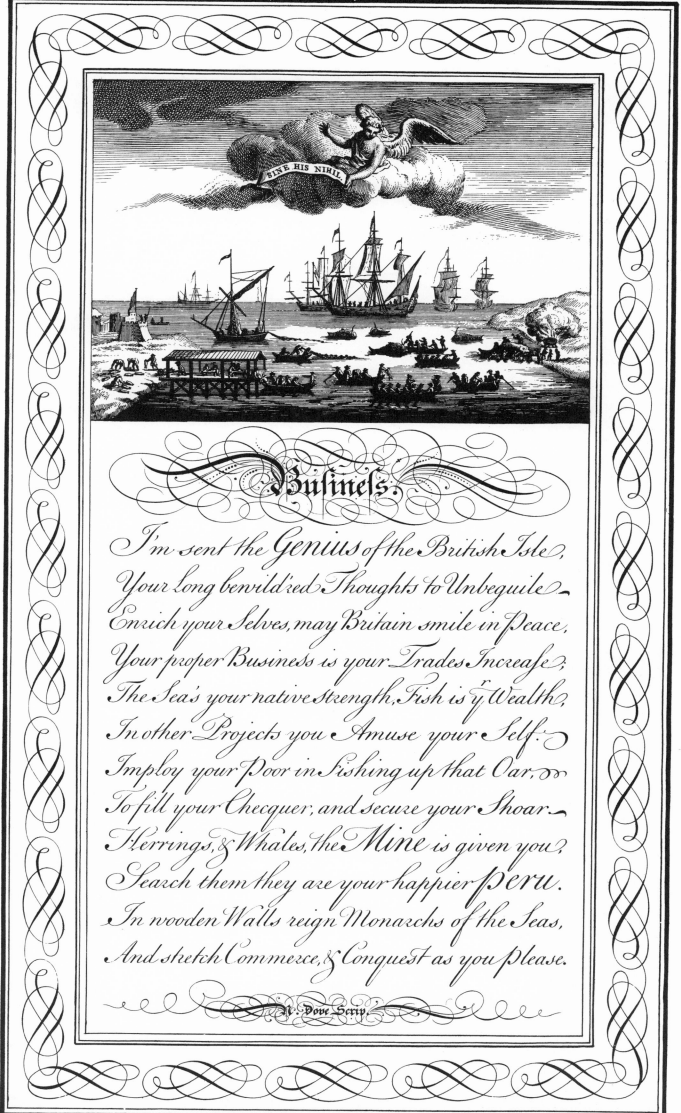

SINE HIS NIHIL.

Business.

I'm sent the GENIUS of the British Isle,
Your long bewild'red Thoughts to Unbeguile
Enrich your Selves, may Britain smile in Peace,
Your proper Business is your Trades Increase;
The Sea's your native strength, Fish is yͤ Wealth,
In other Projects you Amuse your Self.
Imploy your Poor in Fishing up that Oar,
To fill your Checquer, and secure your Shoar.
Herrings, & Whales, the MINE is given you,
Search them they are your happier Peru.
In wooden Walls reign Monarchs of the Seas,
And stretch Commerce, & Conquest as you please.

J. Dove Scrip.

Nᵒ XXXII. 1738. G.B. Sculpſit.

Letters of Business.

Mr James Ellis — Coventry Jan. 2.d 1738.

I have yours of the 23.d past, with the Accot. inclosed; I shall by the next Post remit you a Bill for £127. and desire you to send me the next return, by Job Hill, 3 ps. of Superfine Grey Broad-Cloth; and 3 ps. of Holland about 8.6 ⅌ Ell. ——

I am

Your humble Servant,

William Smith

To Mr James Ellis
in Cheapside London.

Mr William Smith — London Jan. 9.th 1738.

Yours of the 2.d Instant I received as also of the 4.th with a Bill for £127. which is paid, and placed to Your Accot. I have this day sent by Job Hill, accordg to yr Order,

3 ps. Superfine Grey Cloth qt. 108 Yds at 16 ⅌ Yd.	£86. 8. —	
3 ps. fine Holland qt. 47 Ells at 8.6 ⅌ Ell	19.19.6	
	£106.7.6	

To

Mr William Smith
Draper at Coventry.

Your humble Servt

James Ellis.

Emal. Austin Script.

Success.

Success, the Mark no mortal Wit,,
Or surest Hand can always hit?,,
For whatso~~~~~~~~~~e perpetrate,
We do~~~~~~~~~~~rd by Fate.
Which~~~~~~~~~~~~disinherits,
For sp~~~~~~~~~~~t Merits,
Great ~~~~~~~~~~ue Sons,
Of great~~~~~~~~~~lutions,
Nor do t~~~~~~~~~~g forth
Events stu~~~~~~~~~~Worth
But somet~~~~~~~~~~and in their stead
Fortune and Cowardice succeed. Hud. Canto I.

Bickham Fecit.

Business

How bright does the Soul grow with Use and Business? With what proportion'd sweetness does that Family flourish, where but one Laborious Guide steers an order'd & regular Course.

When thou hast BUSINESS of concern to do
With Prudence Act, and Resolution too;
Under whose Conduct you will seldom Fail,
Wisdom and Courage join'd, must needs prevail.

In my Opinion, that Man may be truly said to live, and enjoy his Soul, who giving his Mind to Business, pursues a Reputation by some commendable, Famous Action or honest Art.

Jo. Champion Scr.

MODICE ET ASSIDUE.

Success in Business;
Or, the Arts of Thriving.

The Arts to be used as means of Thriving in the World, are no other than those of an ingenious Industry and unreproveable Integrity, the two best & most solid Bases of a prosperous Condition.

When Business calls us to unfurl the Sails,
And o'er the Surface scud before the Gales;
Presence of Mind, and Courage in Distress,
Are more than Armies to procure Success.
The Sire of Gods and Men, by his Decrees,
Forbids our Plenty to be bought with Ease.

Providence is commonly Indulgent to the honest Endeavours of industrious Persons, that the more laborious they are in their Employments, the more they Thrive and are blessed in them.

Would'st thou be Rich be Diligent.

Bickham *Sculpsit.*

Nº XXXIII. MDCCXXXVIII.

Letters of Credit.

London Nov.^r 2, 1738.

Sir

The Bearer M.^r Thomas Holt, being on his Travels, may have Occasion for Money; Please to furnish him as his Occasions require, taking his Receipts, and your Draughts for the Value shall receive due Honour, from

A Mons.^f Boitard,
Banquier, a Paris.

Your humble Servant

Abel Cash

Paris, 5 Decem.^r 1738.

S^r,

The Bearer Mons. Jean Soir, will have Occasion for Seventy Pounds; therefore request you would Advance him the said Sum, or such Part as he shall require, and take his Bill on me for the same, I am, S^r

To M.^r
John Stout, Merchant,
In London.

Your most hum.^ble Serv.^t

Louis D'Or.

A Letter of Credit.

Sir, London Sep.r 2, 1738.

Please to furnish the Bearer Mr John Meanwell, the Sum of Twenty Pounds, as he shall require the same, & place it to my Account, for which this Letter of Credit with his Receipt shall be your Voucher and Warrant, giving upon Payment a Line or two of Advice, to

To

Mr Nich.o James
Merch.t in Hull.

Your real Friend, and humble Serv.t,

Sam.l Standfast.

Receiv'd October 1. 1738 of Mr Nicholas James, Twenty Pounds by Vertue of Mr Sam.l Standfast his Letter of Credit, of 2d Sep.r last for the said Sum

£ 20.—.—

Pr Jn.o Meanwell.

W. Clark Scripsit.

Promises.

Let your Promises be sincere; and so Prudently considered as not to exceed the reach of your Ability; He who Promises more than he is Able to Perform is False to himself; and he who does not Perform what he has Promised, is a Traytor to his Friend.

Your Promises once made are past Debate;
And Truth's of more Necessity than Fate.

N Dove Scrip.

Reputation, and the Credit of the Merchant.

Good Name in Man or Woman,
Is the immediate Jewel of our Souls.
Who steals my Purse, steals Trash; 'tis something, nothing;
'Twas mine, 'tis his, & has been Slave to Thousands.
But he that Filches from me my Good Name,
Robs me of that which not Enriches him,
And makes me Poor indeed.

By untouch'd Credit and by Foreign Trade,
The Honest Merchant eminent is made;
In Words sincere, in Actions just and fair,
He makes his Credit the effect of CARE.

How careful ought a Man to be in his
Language of a Merchant. It may possibly be
in y'e Power of a very shallow Creature to Lay the Ruin of
the best Family in the most opulent City; and the more so,
the more highly the Merchant deserves of his Country; that
is to say, the farther he places his Wealth out of his
hands, to draw home that of another Climate.

N.º XXXIV. Joseph Champion Scripsit. G. Bickham Sculp.t

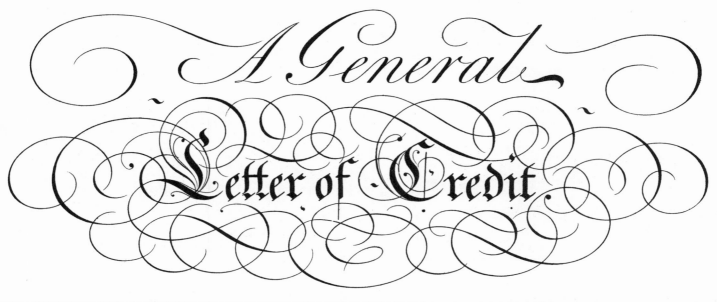

A General
Letter of Credit.

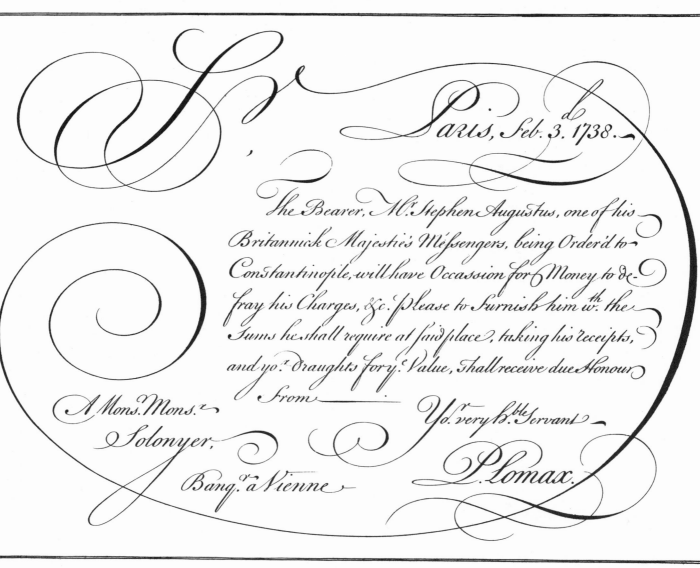

Sir, Paris, Feb. 3. 1738.

The Bearer, Mr. Stephen Augustus, one of his
Britannick Majestie's Messengers, being Order'd to
Constantinople, will have Occassion for Money to de-
fray his Charges, &c. Please to Furnish him wth. the
Sums he shall require at said place, taking his receipts,
and yor. Draughts for yr. Value, Shall receive due Honour
From ——— .

A Mons. Mons. Yor. very hble. Servant
Solonyer,
 P. Lomax.
Bang.r à Vienne

Joseph Champion.
Scripsit.

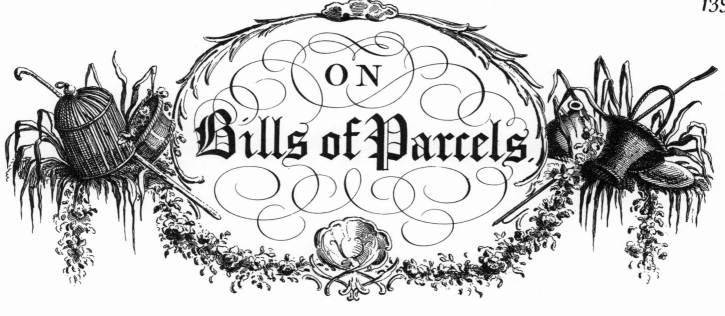

ON Bills of Parcels.

When Goods are sold by one Person to another, the Particulars are wrote in a Bill, with the Price of each Pound, Yard, Ell &c. and the Amount at the End of the Line; and when all the Particulars are set down, and the several Sums they come to placed in Order, one under another, then add them together, and place the Total at the Bottom. This is what is meant by a Bill of Parcels, and is generally given by every Trader to the Buyer; the Form of which is as follows.

Mr. John Saunders Bought of Titus Gill & Compa.
1738.

		C. qr. tt	£. s
Sep. 15th. Sugar...2 hhds nt. wte	17 . 2 . 14	at 1 . 13 . ₱. C.	£29 . 1 . 7½
Raisins...3 Barrels...wte	12 . 1 . 19	at 1 . 14 . do	21 . 2 . 3
Rice...1 Barrel...wte	1 . — . 15	at 2 . 16 . do	3 . 3 . 6
Pepper...1 Bagg...wte	1 . 3 . 19	at 3 . 12 . do	6 . 18 . 2½
Bees-Wax.4 Cakes...wte	2 . 2 . 12	at 1 . 18 . do	4 . 19 . —¾
			£. 65 . 4 . 7¾

N Dove Scrip.

Bickham Sculpsit.

Bills of Parcels.

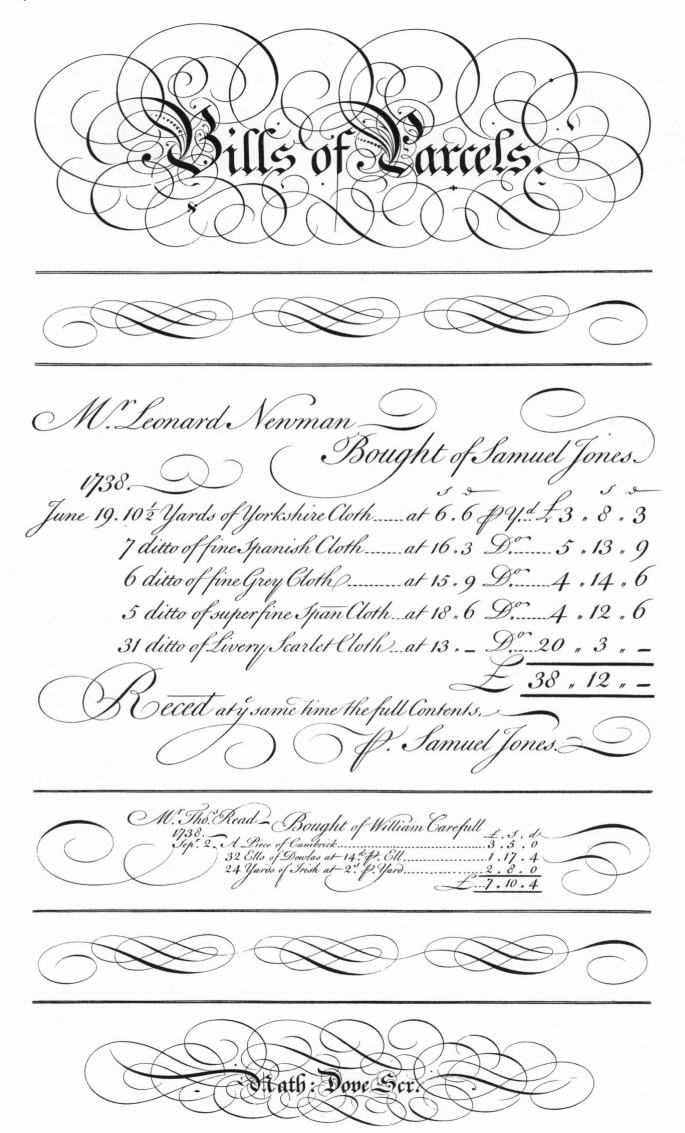

Mr. Leonard Newman

Bought of Samuel Jones

1738.

	£	s	d
June 19. 10½ Yards of Yorkshire Cloth at 6.6 ℔ Yd.	3	8	3
7 ditto of fine Spanish Cloth at 16.3 Do.	5	13	9
6 ditto of fine Grey Cloth at 15.9 Do.	4	14	6
5 ditto of superfine Span Cloth ... at 18.6 Do.	4	12	6
31 ditto of Livery Scarlet Cloth ... at 13. — Do.	20	3	—
£	38	12	—

Reced at ye same time the full Contents,

℔. Samuel Jones.

Mr. Thos. Read — Bought of William Carefull

1738.

	£	s	d
Sep. 2. A Piece of Cambrick	3	5	0
32 Ells of Dowlas at 14.d ℔. Ell	1	17	4
24 Yards of Irish at 2.s ℔. Yard	2	8	0
£	7	10	4

Math: Dove Scr.

On
Promiſſory Notes.

A Promiſſory Note mentioning Order *is indorſible from one Perſon to another; which is done by the preſent Poſſeſſor's writing his Name on the Back of it, and delivering it up to the Party, to whom he intends to aſſign over his Property therein.*

It is unneceſſary to have a Promiſſory Note payable to Bearer *indorſed, if you are ſatisfy'd the Note is good: And if a Note be indorſed, it is neceſſary to write a Receipt thereon, to prevent its being negociated, after it is paid and deliver'd up.*

If the Drawer of a Note refuſes Payment, the Note is good againſt the Indorſer. The delivering up a Promiſſory Note to the Perſon who ſign'd it is a ſufficient Voucher of its being paid, nor is there any Occaſion of writing a Receipt thereon.

Promiſſory Notes, and Book-Debts, if not legally demanded in ſix Years, cannot be recover'd by Law: And if you keep a Promiſſory Note upon Demand, *in your own Hands above three Days, and the Perſon it's upon ſhould fail, the Loſs will be your own; but if he fail within the three Days it will light on the Perſon that paid it you. Let all Notes be made for Value receiv'd, and in the Form of theſe that follow.*

G. Bickham Fecit.

Nᵒ. XXXV.

MDCCXXXVIII

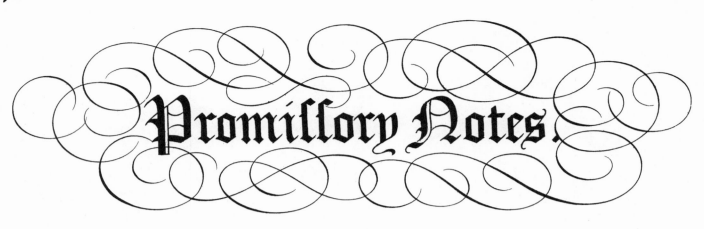

Promissory Notes.

I Promise to pay to Mr William Benson or Order on demand, Twelve Pounds, Value Receiv'd the 23.d of March 1738.

£ 12. — . — John Bonner.

I Promise to pay to Mr Charles Davis, or Bearer, on demand, Five Pounds For Value Reced, the 31.st of May 1739.

£ 5. — . — P William Johnson.

I Promise to pay to Mr Conrade Masters, or Order, Three Months after date, Fifty Pounds for Value Receiv'd. Witness my hand this 29.th of April 1739.

£ 50. — . — George Honeywood.

N: Dove Scrip.

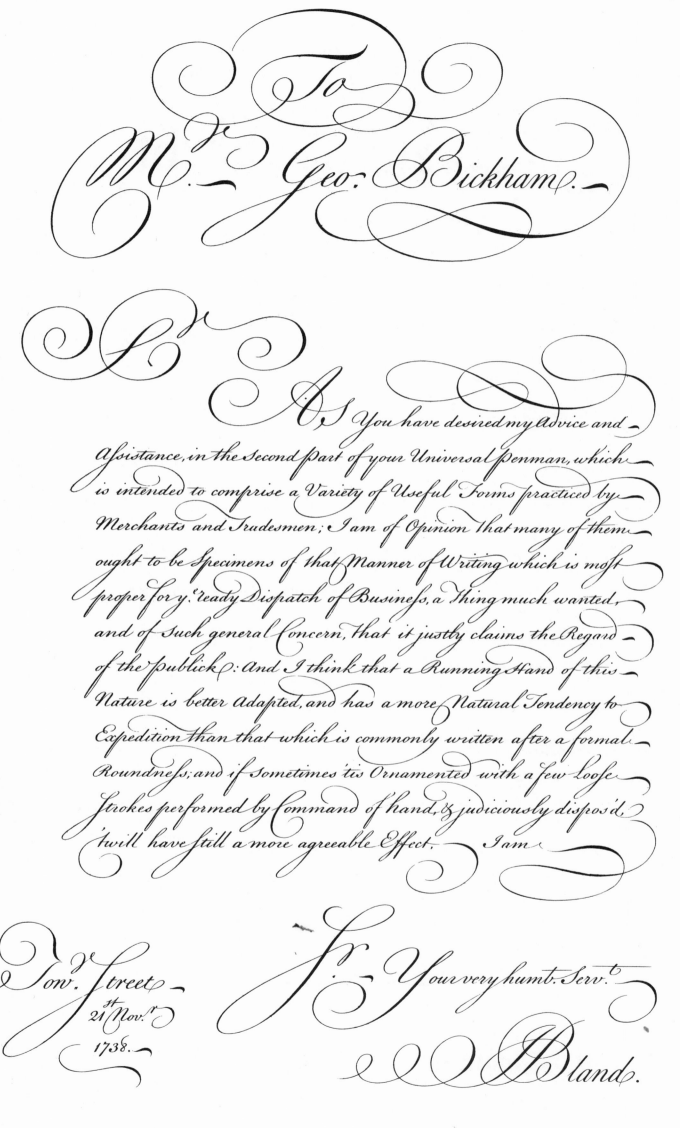

To
Mr. Geo. Bickham.

Sr.

As You have desired my Advice and
Assistance, in the Second Part of your Universal Penman, which
is intended to comprise a Variety of Useful Forms practiced by
Merchants and Tradesmen; I am of Opinion that many of them
ought to be Specimens of that Manner of Writing which is most
proper for yͤ ready Dispatch of Business, a Thing much wanted,
and of Such general Concern, that it justly claims the Regard
of the publick: And I think that a Running Hand of this
Nature is better Adapted, and has a more Natural Tendency to
Expedition than that which is commonly written after a formal
Roundness; and if Sometimes 'tis Ornamented with a few Loose
Strokes performed by Command of hand, & judiciously dispos'd,
'twill have still a more agreeable Effect. I am

Tow. Street
21ˢᵗ Novʳ.
1738.

Sr. Your very humb. Servᵗ

Bland.

A Bill of Debt.

Memorandum, That I Thomas Simpson, of the parish of St. Dunstan in the East, Citizen and Sadler of London, do owe and am indebted to Simon Johnson, of the said place Grocer, the sum of Forty pounds, of good and lawful Money of Great Britain, which sum I promise to pay to the said Simon Johnson, his Executors, Administrators, or Assigns, at, or upon the tenth Day of September next ensuing the Date hereof: In Witness whereof, I have hereunto set my Hand and Seal, this second day of December, in the Year of our Lord, one Thousand, seven hundred, and Thirty eight.

Sign'd, Seal'd, and Deliver'd,
(being first Legally Stamp'd)
in the Presence of,
 Amos Nimo,
 Saml. Jacobs.

Thomas Simpson.

Emanuel Austin Scripsit, 1738.

ADVICE TO Young Tradesmen, &c.

With a vicious Companion it's hard to retain Innocence, be therefore very cautious in chusing your Company.

The Pen an Inſtrument tho'ſmall,
Is of great Uſe and Benefit to all,
Truſt rather to your Fingers Ends,
Than to the Promiſes of Friends.

Be very cautious how you become Security for any one, especially beyond your Ability: He that is Security for a Stranger ſhall smart for it; and he that hateth Suretiſhip is Sure.

Joſeph Champion ſcripſit 1738.

N.º XXXVI. G. Bickham ſculp.

N.° ⟨30.⟩ —

I Promise to pay to the Honourable John Nash Esq.ʳ or Bearer, on Demand, two hundred and twenty pounds,

London the 27ᵗʰ Day of March 1739.

For Robinson, Watts, & Self,

£ 220,—,—

Abraham Inns.

N.° 56.

London April 2. 1739.

Promise to pay to Mr. Timothy Comings, or Bearer, on Demand, three hundred twenty seven pounds ten Shillings and six pence, for my Master James Robins,

£ 327, 10, 6

Charles Banko

N.° 62.

I Promise to pay to the Royal African Company, or Bearer, on Demand, two thousand six hundred Pounds,

London the 3ᵗ Day of May 1739.

For Mess.ʳˢ Oliver & Hanson,

£ 2600.

William Surepay.

E, Austin Scripᵗ

ON PROMISES.

My Promise, and my Faith shall be so sure,
As neither Age can change, nor Art can cure.

Be very Careful in your Promises,
and just in your Performances, and
remember it is better to Do and not
Promise, than to Promise & not Perform.

Perform thy Promise, keep within Faith's bounds,
Who breaks his Word, his Reputation Wounds.

N. DOVE, SCRIPSIT.

Acquittances.

Receiv'd the 3d June 1739. of Mr William Chapman Forty five pounds, nineteen Shillings, and Six pence, in full For my Master Thomas Singleton

£45 „ 19 „ 6 ⌽ Thos. Trueman.

Receiv'd the 7th July 1739. of the Honourable East India Compa. two thousand five Hundred Pounds, fifteen Shillings, in full For Mr Jonathan Simpson and Company

£2500 „ 15 „ — ⌽ James Chambers

Receiv'd the 19 Augt. 1739. of Mr Marmaduke Williamson twenty pounds, in full For a Quarters Rent due at Lady day Last For my Master Timothy Lambert

£20 „ — „ — pr. Thomas Winter.

A. Dove, scrip.

The Produce of different Lands;

AND, THE

Industrious Merchant.

This Corn produces, there rich Wines abound,
Here fruit-Trees laden Branches hide y⁴ Ground:
Without manuring, there kind Nature yields
Luxuriant Pastures, and the Grassy Fields.
On Tmolus hill you see the Saffron grow,
And Ivory where Indus's streams o'erflow:

Sabean shrubs weep Incense, Balsam, Gums;
The martial Steel from Chalyb's River comes;
The beaver-stones on Pontus's shores are found;
Olympic Mares feed on Epirus Ground.
To every Land great Nature hath assign'd
A certain Lot, which Laws eternal bind.

Dove

It is the industrious Merchants Business to collect
the various blessings of each soil and climate, and with
the product of the whole, to enrich his Native Country.

Scrip

N.º XXXVII.

G.B. sculp.

Receipts.

Nov.^r 15. 1739.

Receiv'd by the hands of M.^r Silas Thorn on Ord.^r of S.Gore Esq.^r
thirteen pounds seventeen shillings in Money, Allow'd for taxes 33. in
all Fifteen pounds ten shill.^s being for half a years Rent due at Michmas
last, from Capt. James Dave.

£ 15,,10,,0 ⅌ Pereaule.

Rece'd May. 21.^o 1739, of the R.^t Reverend Nathanael Lord Bishop of
Durham, by the hands of M.^r Jacob Torriano, the sum of ninety pounds, &
is in full for three Quarterly paym.^{ts} of my Annuity, due at Michmas, Xtmas, & Lady Day,

£ 90 ⅌ Jamima Lovely.

J. Champion scr.

Mentor's Description.

Of the Plenty of Creete;

Apply'd to the British-Nation.

This Island, said he, admired by all Strangers, is more than sufficient to nourish all the Inhabitants, though they are innumerable, for the Earth never ceases to produce her Fruits, if Industry be not wanting; her fertile Bosom can never be exhausted. The more numerous Men are in a Country, provided they be laborious, y more Plenty they enjoy. Telema. L.5.P.104.

GREAT BRITAIN's WEALTH

152

A B C D E F

G

H

I

J

K

L

M

N

O

P

Q

R

S

T

U V W X Y Z

THE
RECEIPT.
TO
Mrs Biddy Floyd.

When Cupid did his Grandsire Jove entreat,
To form some Beauty by a New Receipt;
Jove sent and found, far in a Country Scene,
Truth, Innocence, Good-Nature, Look serene:
From which Ingredients, first the dextrous Boy
Pick'd the Demure, the Aukward, and the Coy:
The Graces from the Court did next Provide
Breeding, and Wit, and Air, and decent Pride:
These Venus cleans'd from ev'ry spurious Grain
Of Nice, Coquet, Affected, Pert, and Vain.
Jove mix'd up all, and his best Clay employ'd;
Then call'd the happy Compossition Floyd.

J. Champion Script St Paul's Church-yard, LONDON.

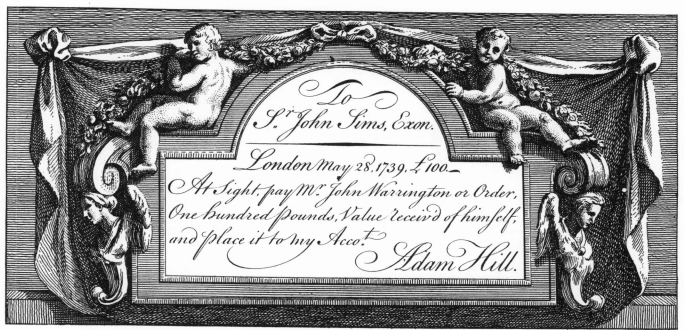

To
Sr John Sims, Exon.

London May 28. 1739. £100.
At Sight, pay Mr. John Warrington or Order,
One hundred Pounds, Value receiv'd of himself,
and place it to my Accot.

Adam Hill.

ON
Bills of Exchange.

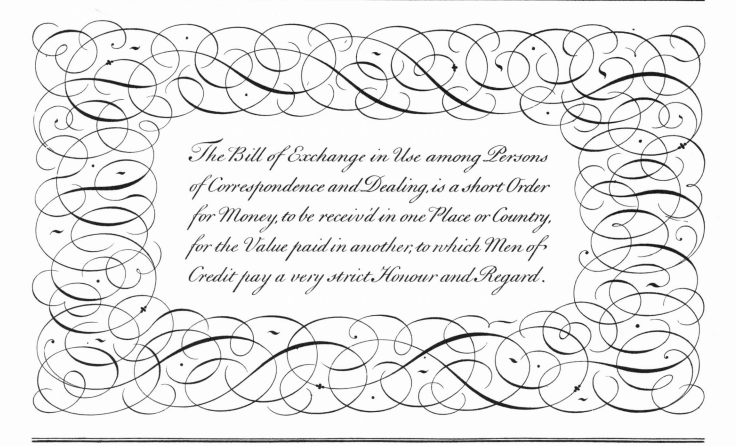

The Bill of Exchange in Use among Persons of Correspondence and Dealing, is a short Order for Money, to be receiv'd in one Place or Country, for the Value paid in another, to which Men of Credit pay a very strict Honour and Regard.

Emanuel Austin Scripsit.

Nº. XXXVIII. Geo: Bickham Sculp. MDCCXXXIX.

Inland

Bills of Exchange.

Bristol, 18 April, 1739. £130.—.

At Sight pay M.ʳ William Longan, or Order, one hundred
and thirty pounds, Value Received of Claudius Devins Esq.ʳ and
place it to Accompt as p Advice from

To M.ʳ Edw.ᵈ Cookes
Merch.ᵗ in London.

John Wilkinson

London, 5 May 1739. £9. 16.

At ten Days Sight pay M.ʳ John Atkinson, or Order, Nine
Pounds sixteen shillings, Value Received of M.ʳ Samuel Johnson,
and place it without farther Advice to Accompt of ———

To M.ʳ Henry Smith
Hosier in Manchester.

David King.

William Rippax.

Scripsit.

Care, that in Cloysters only seals her Eyes;
Which Youth thinks Folly, Age as Wisdom owns;
Fools, by not knowing her, outlive the Wise;
She visits Cities, but She dwells in Thrones.

·C·A·R·E·

What in this Life which soon must end,
Can all our vain Designs intend?
From Shore to Shore why should we run,
Where none his tiresome Self can shun?
For baneful Care will still prevail,
And overtake us under Sail:
'Twill dodge the great Man's Train behind,
Out-run the Doe, out-Fly the Wind.

Cast off all needless and distrustful Care;
A little is enough, too much a Snare.

Dove

Script.

FOREIGN

Bills of Exchange.

sch. gr.

London, April 8.th 1739 for £572 : 10 : 10 St.a a 35 : 1.

At sight, pay this my second Bill, my first not being paid, unto Mr. Lawley Ealing, or Order, the sum of Five hundred & Seventy two Pounds ten Shillings & ten pence Sterling, Exchange at thirty five Schellings and one Grot flemish for £1 St. Value reced of himself, & place it to Acco.t as p Advice from

To Mr. Jan Vanden Velde
Merch.t in Rotterdam. ———

Sr.

Yo.rs Timoleon Trusty.

Rotterd.m May 25. 1739 for ƒ6026, a 35 „ 1.

At double Usance, pay this my second Bill of Exch.a unto Mr. Job Smithson or ord.r Six thousand & twenty six Guilders, Exch.a at thirty five Schellings & one Grot Flemish p £ Ster. Value Rec.t of himself, and place it to Acco.t as p Advice from

Sir.

To Mr. Timol.n Trusty,
Merch.t in London

Yours Jan Vanden Velde.

Jos. Champion.

Scrip.t

THE
King's Custom-House
Explained.

The King's Custom-House, is a Building in Sea-Port Towns where all the Customs are receiv'd, and a Duty paid by the Subject to the King upon Importation or Exportation of Commodities: So called, because Tonnage and Poundage were only granted by Parliament for certain Years till the time of *Henry* VI, but then constantly and perpetually; thence called Customs or Customary Payments: And all Goods or Merchandize exported or Ship'd off before Custom is paid, or security given, forfeited. 12 Car. II. cap. 4. Reviv'd 6. W. and M. cap. I.

Juſt Impoſts fix'd, and Cuſtoms ſettled right,
Support our Strength, and diſtant Friends unite;
Commerce extend, and foreign Riches bring,
To crown with Plenty, Britain and her King.

Nº. XXXIX.

G. Bickham Fecit.

Bills of Entry.

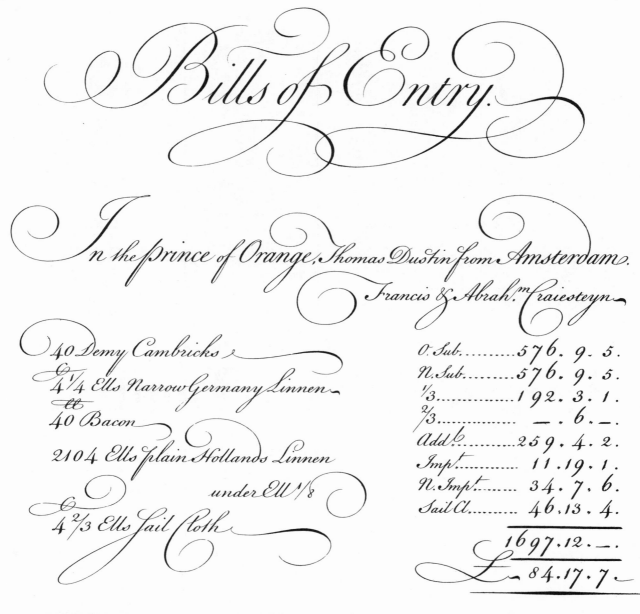

In the prince of Orange, Thomas Dustin from Amsterdam.

Francis & Abrah.ᵐ Craiesteyn

40 Demy Cambricks	O. Sub.	576. 9. 5.	
4¼ Ells Narrow Germany Linnen	N. Sub.	576. 9. 5.	
40 Bacon	⅓	192. 3. 1.	
	⅔	—. 6. —.	
2104 Ells plain Hollands Linnen	Add.ᵈ	259. 4. 2.	
	Imp.ᵗ	11. 19. 1.	
under Ell ⅛	N. Imp.ᵗ	34. 7. 6.	
4⅔ Ells Sail Cloth	Sail Cl.	46. 13. 4.	
		1697. 12. —.	
	£	84. 17. 7.	

In the Bonadventure, Theophilus Lemmington from Jamaica

Solomon Chauncey.

20 pounds Succado	O Sub.	112. 7. 3.	
11 Mahogany plank	N Sub.	112. 7. 3.	
43¾ Muscovado Sugar	⅓	37. 9. 1.	
1536 pounds Pimento of the Gro:	⅔	33. 6. 11.	
4½ Spanish Cocoa	N. Imp.ᵗ	46. 11. —.	
		342. 1. 6.	
	£	17. 2. 1.	

Written and Computed by John Bland

Of the Academy in Tower Street.

A Foreign Chest full of Riches.

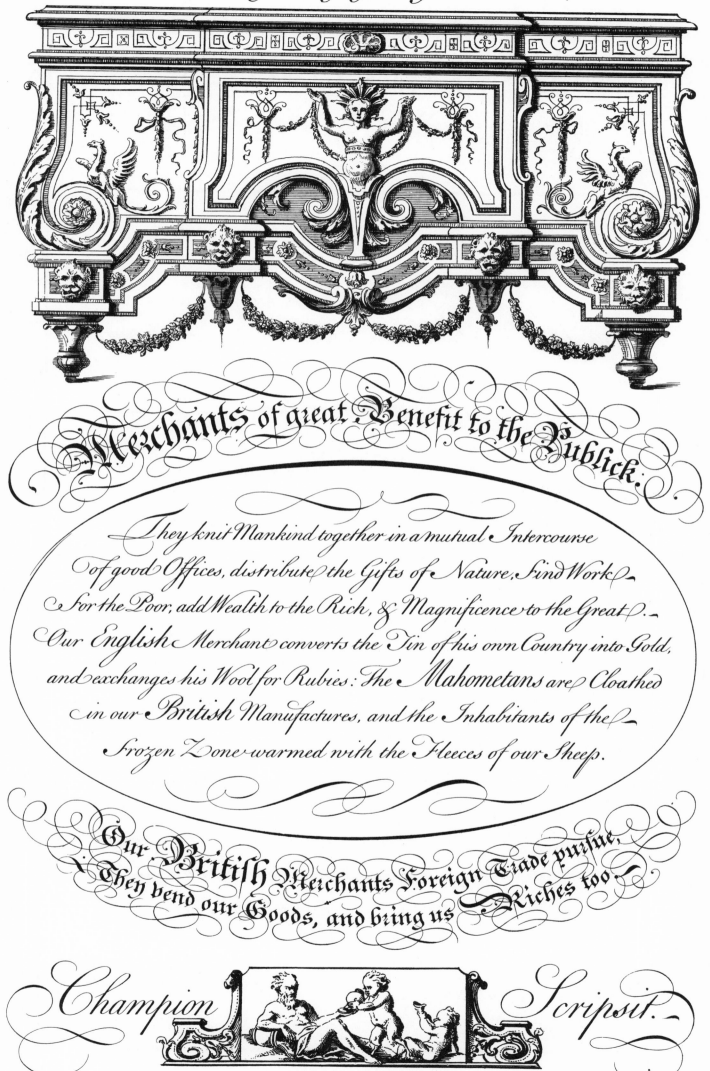

Merchants of great Benefit to the Publick.

They knit Mankind together in a mutual Intercourse
of good Offices, distribute the Gifts of Nature, find Work
for the Poor, add Wealth to the Rich, & Magnificence to the Great.
Our English Merchant converts the Tin of his own Country into Gold,
and exchanges his Wool for Rubies: The Mahometans are Cloathed
in our British Manufactures, and the Inhabitants of the
Frozen Zone warmed with the Fleeces of our Sheep.

*Our British Merchants Foreign Trade pursue,
They vend our Goods, and bring us Riches too.*

Champion *Scripsit.*

Geo: Bickham Sculpsit.

A
Letter to a Factor.

London June 3. 1739

S.r

Pray send me ℔ the first opportunity, 50 P.s of your best Linen, which I hope you will procure for me at a reasonable price, and draw on me for the Amount, which shall receive due Honour, from

To
M.r John Cooper
In Dublin.

Your humble Servant
Charles Shorter.

The Factor's Answer.

Dublin July the 5. 1739

S.r

I have sent you by the Swan, John Smith Com.r 50 P.s of very good Irish Linen, I think them not inferior to any Production in Holland: The Invoice and Bill of Lading are inclosed; as also a Bill for the Charge, I am

To M.r Cha. Shorter
Merch.t in London

Your humble Servant
John Cooper.

E: Dawson, scrip.

Excise is a Duty charged on Beer, Ale, Cyder, Vinegar, Soap, &c.
This Duty was first granted to King Charles II in 1660, and
is one of the greatest Branches of the Revenue: It was formerly
Farmed out, but now it is managed by seven Commissioners for the
King, who sit at the general Excise Office in the Old-Jury London;
they receive the whole Product of the Excise & pay it into the Exchequer;
their Salary is 800 £. per Annum each, and they are obliged by Oath
to take no Fee or Reward but from the King only: The Number of
Clerks, Collectors, &c. are very numerous, and the Charges of their salaries

Amount to above 300,000 £. Per Annum.

Nathaniel *Dove Scrip.*

Nº. XL. G. Bickham Sculp.

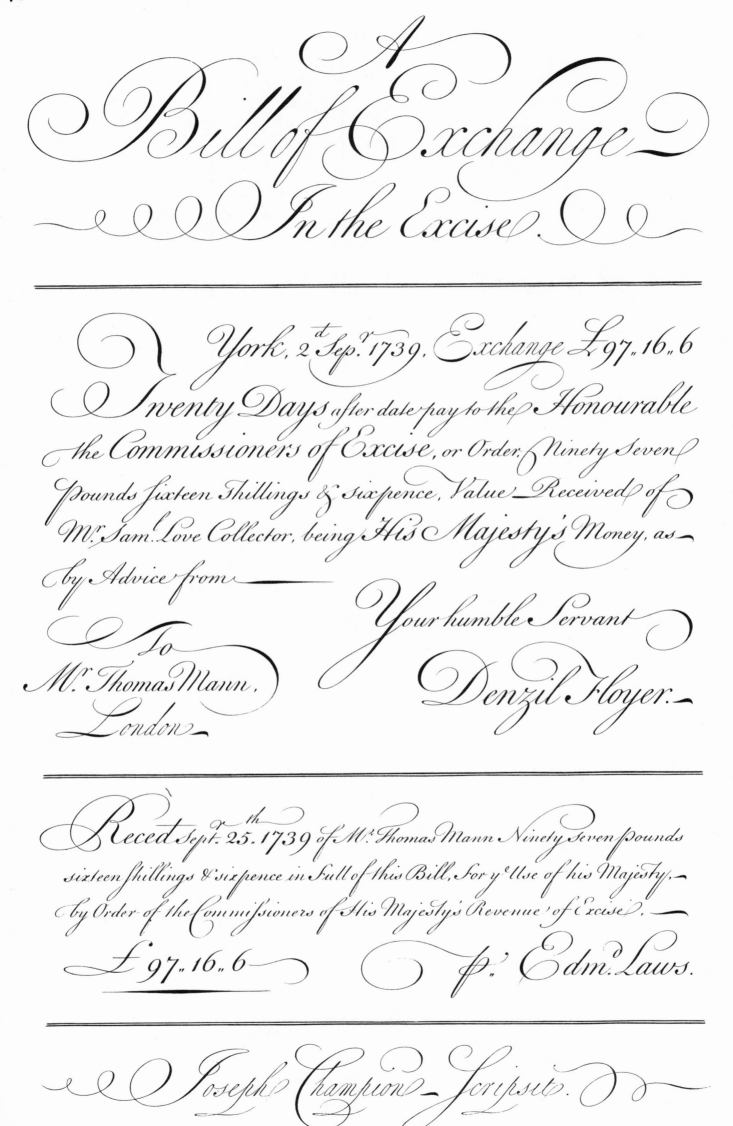

A
Bill of Exchange
In the Excise.

York, 2ᵈ Sepʳ 1739, Exchange £97,,16,,6

Twenty Days after date pay to the Honourable
the Commissioners of Excise, or Order, Ninety Seven
Pounds Sixteen Shillings & Sixpence, Value Received of
Mʳ. Samˡ. Love Collector, being His Majesty's Money, as
by Advice from —

Your humble Servant

To
Mʳ. Thomas Mann,
London

Denzil Floyer.

Recᵈ Septʳ. 25. 1739 of Mʳ. Thomas Mann Ninety Seven Pounds
sixteen Shillings & Sixpence in Full of this Bill, For yᵉ Use of his Majesty,
by Order of the Commissioners of His Majesty's Revenue of Excise.

£ 97,,16,,6 ℗ Edmᵈ Laws.

Joseph Champion Scripsit.

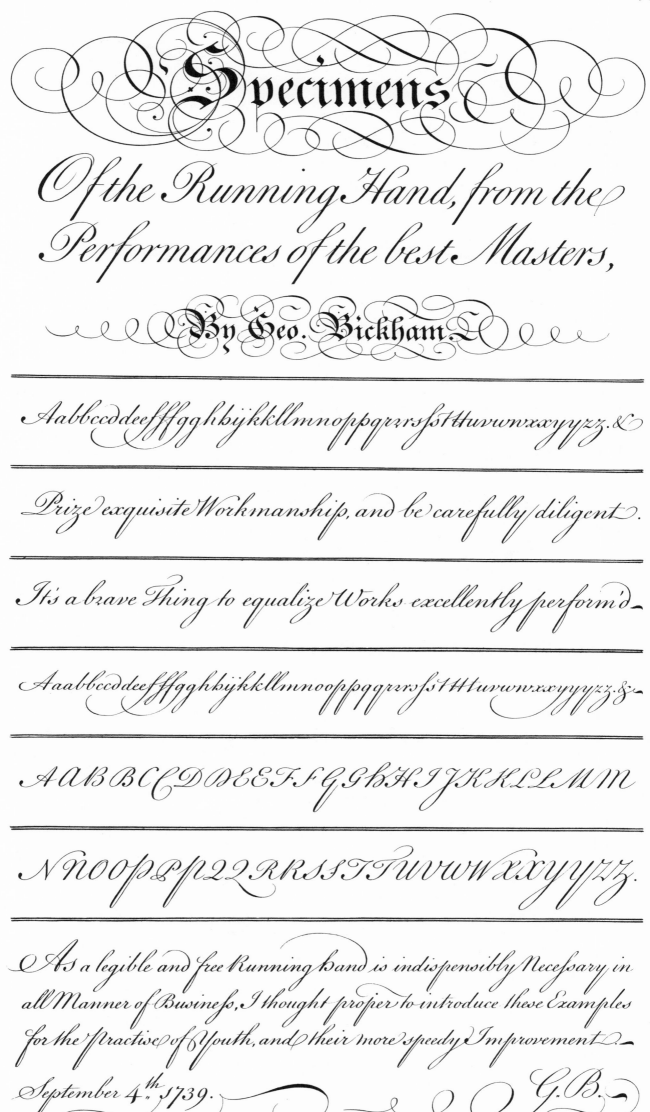

Specimens

Of the Running Hand, from the Performances of the best Masters,

By Geo. Bickham.

Aabbccddeefffgghhijkkllmnoppqrrrsfstttuvvwxxyyzz.&

Prize exquisite Workmanship, and be carefully diligent.

It's a brave Thing to equalize Works excellently perform'd

Aaabbccddeefffgghhijkkllmnooppqqprrrsfsttttuvvwxxyyyzz.&

AABBCCDDEEFFGGHHIJKKLLMM

NNOOPPQQRKSSTTUVVWWXXYYZZ.

As a legible and free Running hand is indispensibly Necesary in all Manner of Businefs, I thought proper to introduce these Examples for the practise of Youth, and their more speedy Improvement

September 4th 1739. G. B.

ON Commission.

Commission is the Authority or Power by which one Person Transacts Business for, or under another, which is commonly by Deed or Writing, duly executed, which the delegated Person produces upon all proper & necessary Occasions, to satisfy those who have a right to examine into it: So in the Army, & in all Offices under ye Crown, a Person is said to have a Commission given him, who had no Power to act before: In Trade, it sometimes means the Power of acting for another, & sometimes the Premium or Reward that a Person receives for his so doing, which is ½, 1, 2, 3, or more per Cent, according to the Nature of the Affair

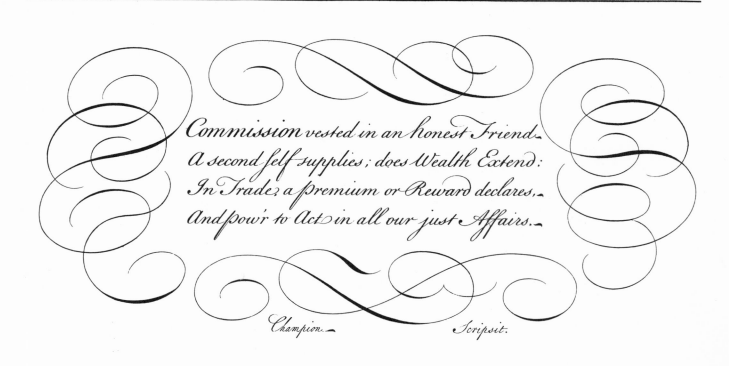

Commission vested in an honest Friend,
A second self supplies; does Wealth Extend:
In Trade, a premium or Reward declares,
And pow'r to Act in all our just Affairs.

Champion. Scripsit.

John Carefull, Factor

INVOYCES

Invoyces shew the *Cost* and *Charges* on *Goods* sent by *Sea*
from one *place* to another; like a *Bill* of *parsels* among *Tradesmen.*
The *person* who sends the *Invoyce* is called the *Factor;* who is
imployed by the *Merchant* abroad; to buy, sell, remit, ship, and
pay *Charges* on *Goods* sent from hence, or brought hither.
Such *Factor* is allowed a certain *Rate per Cent* for his *Trouble,*
which is called *Commission,* & is paid by the *Imployer.*

The *Form* of an *Invoyce* is as follows. ——

Nº XLI.

G.J. Bickham. *sc.*

London September 5, 1739.

Invoice of 4 Bales, containing 90 ps, of Serges, Laden on board the Mary of London, Charles Scotson Master, bound for Lisbon, Consign'd to James Smithson Factor, for his proper Accompt and Risque. Mark, Numbers, Cost and Charges, is as follows, *Viz.*

N.º 3 of 12 Greens, 13 Tawnies
4 13 Scarlets, 12 Blacks
5 10 Violets, 8 Sky-Blue,
6 12 Musks, 10 Crimsons.

For 90 ps. of Serges, cost raw £. 2.16.3 ⅌ ps 253 „ 2 „ 6
Dying, and Drying at 7. 6 ⅌ ps 33 „ 15 „ —
Pressing, Folding, & Tacking 2 „ 15 „ 7
Paper, and Seals — „ 5 „ 2
Canvas, Cordage, & Imbaling 3 „ 14 „ 3
Cocket and Searcher's Fees — „ 13 „ 7
Cartage, Porterage, & Lyterage — „ 7 „ 3
Warfage, Crane, and Dispatch — „ 2 „ 4
 ———— 41 „ 13 „ 2
For my Commission at 2½ ⅌ C.ᵗ ------------- 7 „ 7 „ 4
 £ 302 „ 3 „ —

Errors Excepted

E. Danson.

A COMMISSION,

To the Master of a Ship.

The
Company of English Merchants
For discovery of New Trades.

Do hereby Give and Grant unto Job Lookout Master of the George and Elizabeth, of the Burthen about Two Hundred and Fifty Tons, free Liberty and License to Sail to all or any the Lands, Islands, Ports, Havens, or Territories within the Limits granted to the said Company: Provided never the less upon this express Condition; That the said Master doth fully conform in all things to the Rules, Directions, and Restrictions hereunto annexed, otherwise this License to be Null and Void; and the said Master with his Ship, Goods and Merchandize, to be liable to all Penalties that may by Law be inflicted: Provided also that this License shall be of Force only for One Voyage out and home, and no longer: Dated in London the Tenth day of September, in One Thousand Seven Hundred Thirty and Nine.⸺

By Order of the Governour, Consuls, and Assistants of the said Company.

George John's son Scripsit.⸺

RULES,

Directions, and Restrictions;

To be observed by the within Named Job Lookout,

In his Voyage outwards and homewards.

Viz.

The said *Master* shall not take on board his said Ship, either for the Account of himself or any other Person whatsoever, any *Goods* or *Merchandize*, without a Permit or Warrant from the said Company, or their proper Officer, specifying the Nature, Quantities, Qualities, Kinds, Species, Weights, Numbers, and Package of the said Goods and Merchandize.

The said *Master* upon his Arrival in his designed Port outwards, before any *Goods* or *Merchandize* are unladen, shall deliver to the Company's Agent there, a full and particular Account of all *Goods* and *Merchandize* on board his said Ship, and by whom the said *Goods* or *Merchandize* were put on board in *Great-Britain*, and to whom they were Consigned, which said Account is to be signed by the said *Master*.

And the said *Master* upon his Arrival back at his delivering Port in *Great-Britain*, shall, before he break Bulk, deliver to the said Company, or their proper Officer, a like full and particular Account of his Loading, and by whom the several Species and Quantities of Goods or Merchandize were put on board his said Ship, and to whom they were Consigned, which Account is to be Signed by the said *Master*.

TRUTH.

Truth is the Band of Union, and the Basis of Humane Happiness: Without this Virtue there's no Relyance upon Language, no Confidence in Friendship, and no Security in Promises or Oaths.

Credit obtain'd, Untruth for Truth may pass
As current Coin, tho' underneath 'tis Brass:
But if Perfidious thou but once be found,
Thy Words tho' true, like to Untruth will sound.

Truth is always consistent with it self, and needs nothing to help it out; it is always near at hand, and sits upon our Lips, and is ready to drop out before we are aware: Whereas a Lye is trouble--some, and sets a Man's Invention on the Rack, and one Trick needs a great many more, of the same kind, to make it good.

Nº XLII. G.B. sculp.

The Distinguishing Marks OF A True Fine Gentleman.

WHEN a good Artist would Express any remarkable Character in Sculpture, he endeavours to Work up his Figure into all the Perfection his Imagination can form; and to imitate not so much what is as what may or ought to be. I shall follow their Example, in the Idea I am going to trace out of a fine Gentleman, by assembling together such Qualifications as seem requisite to make the Character compleat. In Order to this, I shall premise in general, that by a Fine Gentleman I mean a Man compleatly qualified as well for the Service and Good, as for the Ornament and Delight of Society. When I consider the Frame of Mind peculiar to a Gentleman, I suppose it graced with all the Dignity and Elevation of Spirit that Human Nature is capable of: To this I would have joined a clear Understanding, a Reason free from Prejudice, a steady Judgment, and an extensive Knowledge. When I think of the Heart of a Gentleman, I imagine it firm and intrepid, void of all inordinate Passions, and full of Tenderness, Compassion, and Benevolence. When I view the fine Gentleman with regard to his Manners, methinks I see him Modest without Bashfulness, frank and affable without Impertinence, obliging and complaisant without Servility, Cheerful and in good Humour without Noise. These amiable Qualities are not easily obtained; neither are there many Men, that have a Genius to excel this Way. A finished Gentleman is perhaps the most uncommon of all the great Characters in Life. Besides the natural Endowments with which this distinguished Man is to be born, he must run through a long Series of Education. Before he makes

his

his Appearance and Shines in the World, he must be principled in Religion, instructed in all the moral Virtues, and led through the whole Course of the polite Arts and Sciences. He should be no Stranger to Courts and to Camps; he must Travel to open his Mind, to enlarge his Views, to learn the Policies and Interest of foreign States, as well as to fashion and polish himself, and to get clear of National Prejudices; of which every Country has its Share. To all these more essential Improvements, he must not forget to add the fashionable Ornaments of Life, such as are the Languages and the bodily Exercises most in Vogue: Neither would I have him think even Dress it Self beneath his Notice.

It is no very uncommon Thing in the World to meet with Men of Probity: there are likewise a great many of Honour to be found: Men of Courage, Men of Sense, and Men of Letters are frequent: But a true fine Gentleman is what one seldom sees. He is properly a Compound of the various good Qualities that embellish Mankind. As the great Poet animates all the different Parts of Learning by the Force of his Genius, and irradiates all the Compass of his Knowledge by the Lustre and Brightness of his Imagination; so all the great and solid Perfections of Life appear in the finished Gentleman, with a beautiful Gloss and Varnish: every thing he says or does is accompanied with a Manner, or rather a Charm, that draws the Admiration and Good-will of every Beholder.

N. Dove Scrip. Guardian No 34.

G. Bickham Sen.
Sculp.

To

Mr. Joseph Champion

Writing-Master to St. Paul's School.

London

Sr,

As Correctness and Freedom are the Beauties of Writing, and Your Excellency in both Shines so conspicuously in my Universal Penman; it obliges me to request the continuation of your Friendly Assistance, and to write, with all convenient Speed, the Form of an Invoyce: I should be glad to have it a Foreign One, and of Your own Calculation: And since 'tis well known, that you have a peculiar Talent for Striking, either Letters or Flourishes, by Command of Hand; I doubt not but you will embellish it in the most Masterly and Agreeable Manner; and you may depend on my best Endeavours, in the Engraving, to imitate the Beauties of your Original, I am

Sr

Sr, Your most Obliged humble Servt,

Novemr. 3 1739.

G. Bickham.

WISDOM

Happy is the man that findeth wisdom, and the man that getteth understanding. For the merchandise of it is better than the merchandise of silver, and the gain thereof than fine gold. She is more precious than rubies; and all the things thou canst desire are not to be compared unto her. Length of days is in her right hand and in her left hand riches and honour. Her ways are ways of pleasantness and all her paths are peace.

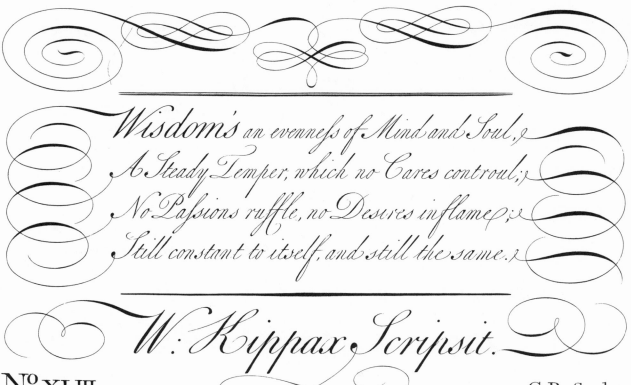

Wisdom's an evenness of Mind and Soul,
A Steady Temper, which no Cares controul;
No Passions ruffle, no Desires inflame;
Still constant to itself, and still the same.

W: Kippax Scripsit.

Nᵒ XLIII.

G.B. Sculp

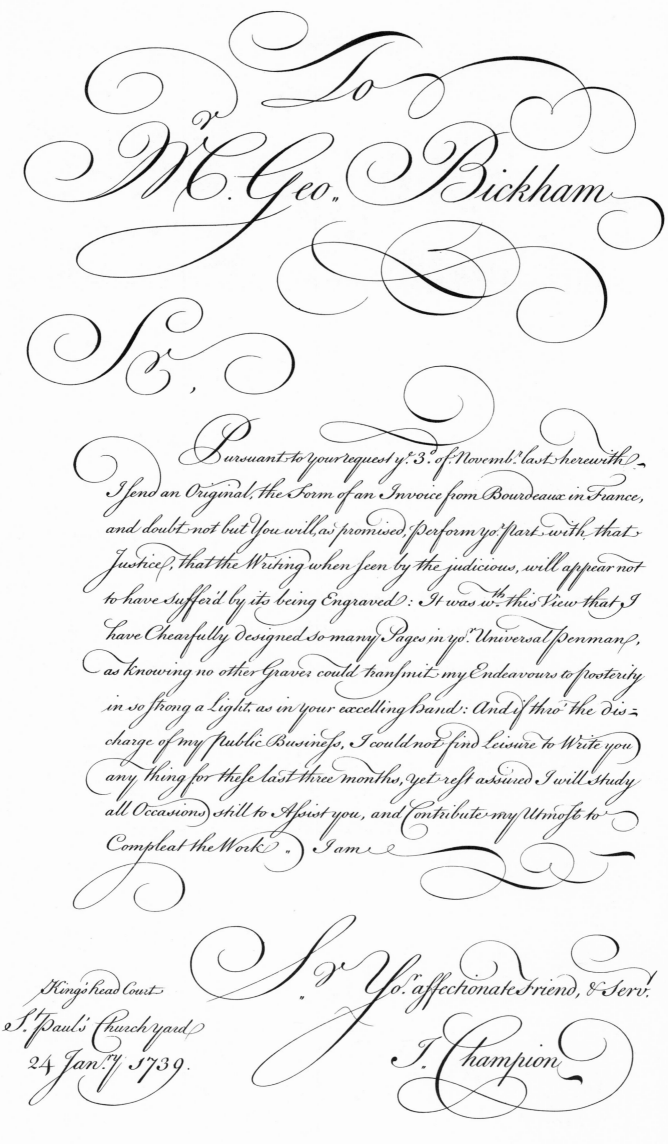

To Mr. Geo. Bickham

Sr,

Pursuant to your request yr. 3. of Novembr. last herewith
I send an Original, the Form of an Invoice from Bourdeaux in France,
and doubt not but You will, as promised, perform yor. Part with that
Justice, that the Writing when seen by the judicious, will appear not
to have suffer'd by its being Engraved: It was wth. this View that, I
have Chearfully designed so many Pages in yor. Universal Penman,
as knowing no other Graver could transmit my Endeavours to posterity
in so strong a Light, as in your excelling hand: And if thro' the dis-
charge of my Public Business, I could not find Leisure to Write you
any thing for these last three months, yet rest assured I will study
all Occasions still to Assist you, and Contribute my Utmost to
Compleat the Work. I am

King's Head Court
St. Paul's Church yard
24 Janry. 1739.

Sr Yor. affecbonate Friend, & Serv.

J. Champion

Bourdeaux, Jan.^th 25. 1739

Invoice of 20 Tons French Wines, Viz. 10 Tons White,

6 Tons, Claret in Tierces.

4 Tons D.º Hhds

Laden by me Walter Bingley, aboard the Augusta Jn.º Frederick

Master, for Acco.ᵗ of Mons.ʳ Philip Jullian, Merch.ᵗ in Caen, & by Bills

of Loading go qʂd to Mr. J. C. Merchant in London, or to his Assigns Viz.ᵗ

Tons. Hh.ᵈ Tier.		Crowns	Livres. Sols. den.
4 „ 0 „ 0	Langoon Wine of Jean Faros........ at 29 is		348 „ — „ —
3 „ 0 „ 0	Barsac D.º De La Motte 28		252 „ — „ —
3 „ 0 „ 0	Priniac D.º Jaques Nicoleau 36		324 „ — „ —
2 „ 0 „ 0	Claret in Hhds D.º 30		180 „ — „ —
2 „ 0 „ 0	D.º of Mess.ʳˢ Julien & leSoy .. 27		162 „ — „ —
2 „ 2 „ 0	d.º Tierces, Mons.ʳ Mercier 27		202 „ 10 „ —
2 „ 2 „ 1	D.º in Tierces, O. Gourdin 28		224 „ — „ —
0 „ 2 „ 2	D.º Jean Le Jour & P.ʳ Liblon .. 27		67 „ 10 „ —

N.º 1 to 20.

20 „ — „ — 1760 „ — „ —

Charges Viz.ᵗ

To Custom in the Fair and Out .. Liv. 369 : — : — .

Horsehire & Expences in buy.ᵍ at 15 Sols... 15 : — : —

Boatage and Stow.ᵈ each at 6 Livres.. 12 : — : — .

Brokerage 30 Sols ⅌ Ton 30 : — : —

The Mat.ʳ 30 Sols, & Charter Party 2 ⅌ T.º 32 : — : — .

The Poor's Box 2 Sols ⅌ Ton 2 : — : —

Livres 460 : — : —

To my Commission on 2220, a 2 ⅌ C.ᵗ 44 : 8 : —

504 „ 8 „ —

The Whole Adventure .. 2264 „ 8 „ —

Errors Excepted

⅌ W. Bingley.

Champion Scr.

A Bill of Lading.

Shipp'd by the Grace of God, in good Order, and well Condition'd, by Lumley & Soames, in and upon the good Ship call'd the Sea-Nymph, whereof is Master, under God, for this present Voyage, John Parker, and now Riding at Anchor in the River of Oporto, and by God's Grace bound for London, to say Twenty Pipes of Red Oporto Wine, for Acco.t & Risque of Mr. Andrew Dixt, Merch.t in the said place; being Mark'd and Number'd as in ye Margin, and are to be Deliver'd in the Like good Order, & Well Condition'd, at the aforesaid Port of London, (the Danger of the Seas only Excepted) unto the said Mr. Andrew Dix or to his Assigns, he or they paying Freight for the said Goods Thirty Shillings Sterß. ℘ Tun, with Primage & Avarage accustom'd; In Witness whereof the Master or Purser of the s.d Ship hath affirm'd to Three Bills of Lading, all of this Tenor and Date; the one of which three Bills being accomplish'd the other two to stand Void: And so God send the good Ship to her desir'd Port in safety, Amen. Dated in

AD
20 pipes.

Oporto May. 30.th 1739.

T. TREADWAY, Junr.

Scripsit.

TELEMACHUS

HIS

Description of the City of Tyre;

Apply'd

To the City of London.

This great City seems to float upon the Waters, and to be Queen of all the Seas; the Merchants resort hither from all parts of the World, and its Inhabitants are the most famous Merchants in the Universe. When Men enter into this City, they cannot think it to be a place belonging to a particular People, but rather to be a City common to all Nations, and the Center of all Trade and Correspondence.

THIS ancient City is for Trade compleat,
Her wealthy Merchants Eminently Great;
Her Thames supports unnumber'd Ships of Pride,
That float, with Plenty, down her silver Tide.

Champion Scrip.

Nº XLIV.

G. Bickham Sculp.

Acco.t of Sales of 2765 Ells of Brown Ozenbrigs, 1112 Yards of Blue Hestforda, 27.. of Black Cloth, q.t 39 Yds, 40 Pair of Stockings, & 175 ells of Bag holland, rec.d from on board the Succefs Capt. Lowimar Master, from London, on Acco.t of Emanuel Potts, is

Dr. — — **Cr.**

To Portage of the Whole £ 0..17..6 —

To Commission on Sales 5 p.Ct..... 11..12..3¼

To Storage 2½ p.Cent...... 5..16..1½

 —— 18..05..10¾

To M.r Potts, for the Net Proceed 213..19..8¾

 £ 232..05..7½

By Sam.l Land, sold him 2765 ells of Ozenbrigs, at £8½ p.Ell... £91..18..6½

By 1112 yds blue linnd. d.o at 7½ p.yd... 34..15.. —

By Rent, for 39 yds of Cloth a 15.s ... 29..5.. —

By Scot, sold 40 p.r Hose, at 7/10 ea.r ..15..13..4.

By D.o for 175 ells Bag holld. a 6.3 ... 54..13..9.

 £ 232..05..7½

Errors excepted — Port Royal in Jamaca — May 5.th 1740.

Champion Scr.

ON Merchants Accompts

Merchants Accompts or the Italian method of Book-keeping by double Entry, as now practis'd by Merchants, may truly be allow'd to comprehend all Excellencies in Accounting: For as the Judicious Author of the Gentleman Accomptant, Observes: All other methods which particular Persons have occasionally instituted for their own private Concerns are found in this ; and all those methods whatsoever they are, were, or may be invented for the use of any Acco.ts are parts of, & as it were taken out of the Debitor, & Creditor; and so much as they want of that, however in private concerns serviceable enough, just so much they want of desireable perfection.

Nathaniel Dove.

Scrip.t

Dr Mr Simeon Young's Acco.t Curr.t **C.r**

Liv.. Sol. Den.

1740.		Liv.. Sol. Den.
March 31	To Cost & Charges of 10 P.s Brandy of the James..	1290.6.5
Ap.l 7	To d.o of 20 P.s Prunes & ½ Tun Wine of the Jane..	732.5.—
	To my Bill of 72 Cr: 5 Sol. remitted him on M.r Jonathan Robinson..........	216.5.—
June 16	To Postage of Letters to this Day.........	1.15.—
	To Ballance transferr'd to yo.r Credit in new Acco.t	49.—7
		2289.12.—

Liv.. Sol. Den.

1740.		Liv.. Sol. Den.
Mar. 31	By my Bill on him in Favour of M.r Francis Amots of 315 Cr: 12 Sol...	945.12.—
May 15	By his Remittance at 10 days sight of 266 Cr: on Mess.rs Power & Fran Larom.	798.—.—
19	By his Remittance at 8 days sight of 182 Cr: on M.r James Sims of Rochel...	546.—.—
		2289.12.—

Bourdeaux June 20. 1740. Errors excepted.

Leon. d. Barreau.

E. Austin Scrip.

Letters

ON

Several Occasions.

EXTRACTED

From some Original Curious Specimens
of Epistolary Writing, in Prose and Verse,

Compos'd by the best Hands,

In order to habituate Youth to an easy and elegant
Expression, as well as a Graceful Manner of
Writing, and Striking by Command of Hand.

Written,

With the friendly Assistance of several of the most Eminent Masters,
And Engrav'd by G. Bickham Sen.ʳ

Cadmus did first the wond'rous Art devise — Of Painting Words, and Speaking to the Eyes.

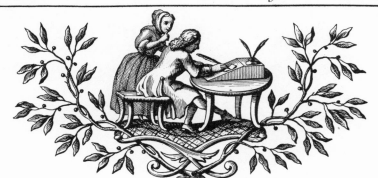

N.º XLV.

G. Bickham Fecit.

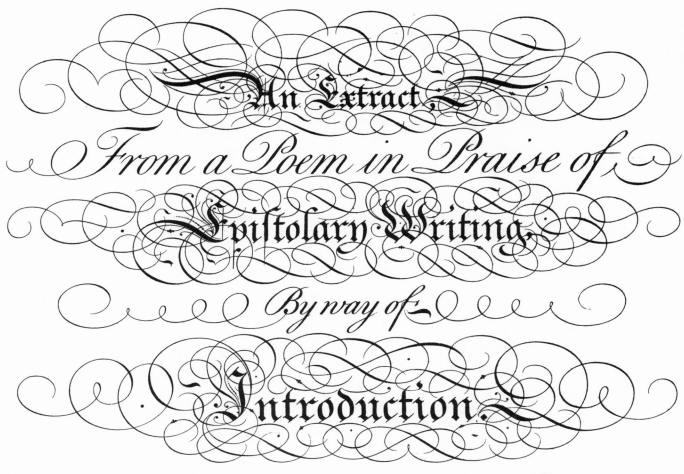

An Extract,

From a Poem in Praise of,

Epistolary Writing,

By way of

Introduction.

Blest be the Man! his Memory at least,
Who found the Art, thus to unfold his Breast;
And taught succeeding Times an easy way
Their Secret Thoughts by Letters to convey;
To baffle Absence, and secure Delight,
Which, 'till that Time, was limited to Sight.
The parting Farewel spoke, the last Adieu,
The less'ning Distance past, then loss of View;
The Friend was gone, w^ch some kind Moments gave,
And Absence separated, like the Grave.

When for a Wife the youthful Patriarch sent,
The Camels, Jewels, and the Steward went,
And wealthy Equipage, tho' grave and slow,
But not a Line, that might the Lover show.
*The Ring and Bracelets woo'd her Hands & Arms;
But had she known of melting Words, the Charms
That under secret Seals in Ambush lie,
To catch the Soul, when drawn into the Eye;
The fair Assyrian had not took his Guide,
Nor her soft Heart in Chains of Pearl been ty'd.

Compos'd by a Lady.

*Gen. Chap. 24. Ver. 53.

Nathaniel Dove scr.

George Bickham
Sculp.

A Letter from a Nobleman,
TO A SCHOOL-MASTER.

May 10.th 1740.

Sir,

Hearing of Your Great Abilities, and having a Boy of Genius, and other Good Dispositions, on whom I am willing to bestow a Liberal Education; I would to that End commit him to Your Care and Discipline. I am very desirous he may at last appear Such as shall reflect Honour on the Memory of his Friends and Benefactors, which, under Your Tuition, I trust he will do.

Your best Endeavours however in his Behalf shall not fail of a Suitable Esteem and Recompence, from,

Sr

Yours,
&c.

E, Austin scrip.

Answer to the Foregoing Letter.

Most Noble Lord,

For the Honour you intend me and the Confidence you place in me, by committing to my Care so promising and fine a Youth, Your Lordship has my most humble thanks; Your Generosity, My Lord, is too well known to the World, for any Man to question your Gratitude, especially my Self who have tasted so largely of your Beneficence. So that you may rest assured, if he is as ready and willing to learn as I am to teach, he will in due time answer all your Expectations, and it will be the utmost Satisfaction to me to have served so Noble a Patron.

I am

My Lord,

Your Lordship's most Obliged and most Obedient Humble Servant

May 13th 1740.

&c

Written by N. Dove, Master of the Academy in Hoxton.

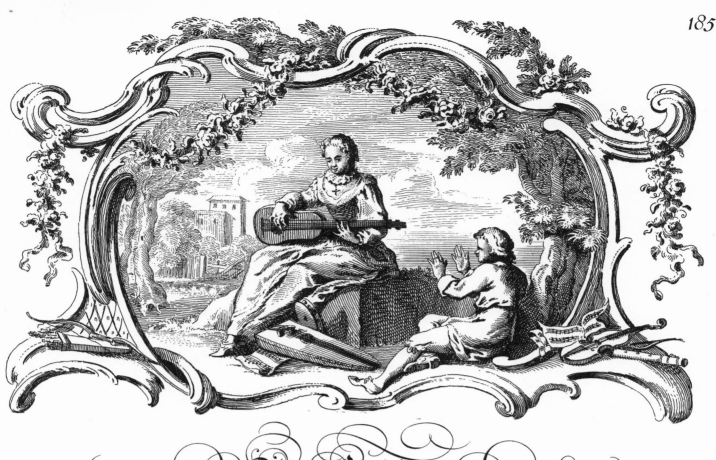

An Epistle
To the Countess of EXETER,
Playing on the Lute

What Charms you have, from w.^t high Race you sprung,
Have been the pleasing Subjects of my Song
Unskill'd & young, yet something still I writ,
Of Candish Beauty join'd to Cecil's Wit:
But when you please to Show the lab'ring Muse,
What greater theme your Musick can produce,
My babling Praises I repeat no more;
But hear, rejoice, stand silent, and Adore.
The Persians thus, first gazing on the Sun,
Admir'd how high 'twas plac'd, how bright it Shone,

But, as his Pow'r was known, their Thoughts were rais'd,
And soon they Worship'd, what at first they prais'd.
Eliza's Glory lives in Spencer's Song;
And Cowley's Verse keeps Fair Orinda young:
That as in Birth, in Beauty You Excel,
The Muse might dictate, and the Poet tell:
Your Art no other Art can speak; and You,
To show how well you play, must play anew:
Your Musick's pow'r your Musick must disclose;
For what light is, 'tis only Light that shows.

 Champion

 Scripsit.

N.º XLVI.

G.B. sculp.

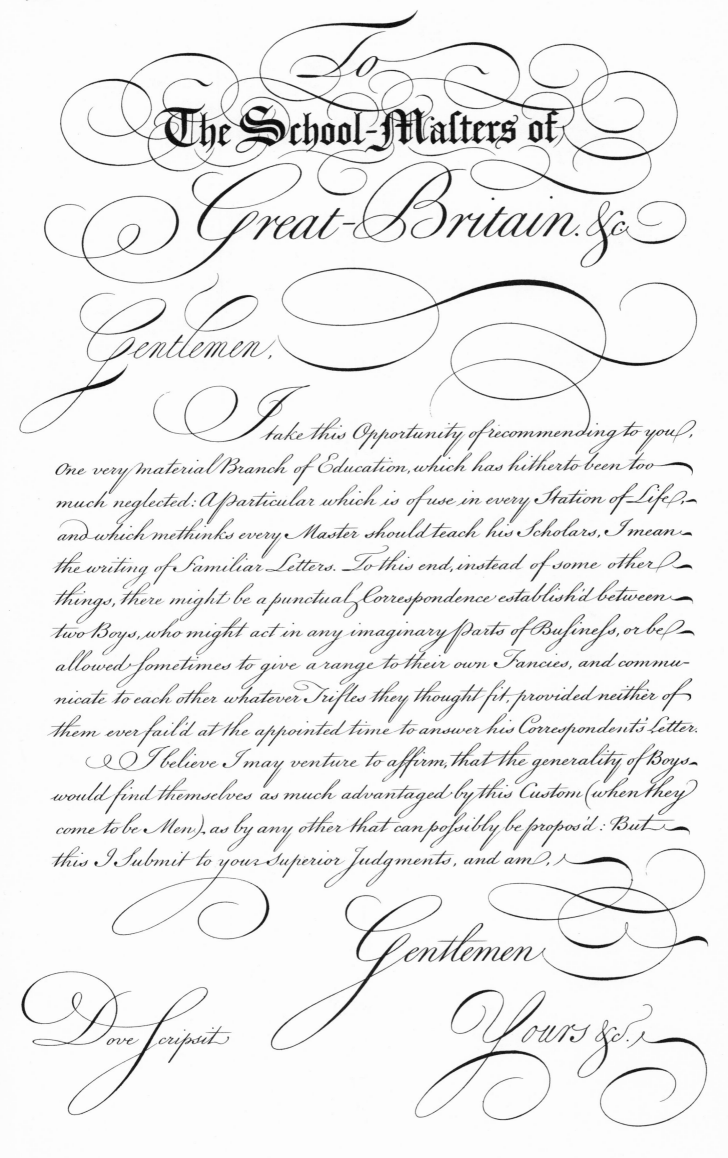

To
The School-Masters of
Great-Britain. &c

Gentlemen,

I take this Opportunity of recommending to you, One very material Branch of Education, which has hitherto been too much neglected: A particular which is of use in every Station of Life, and which methinks every Master should teach his Scholars, I mean the writing of Familiar Letters. To this end, instead of some other things, there might be a punctual Correspondence establish'd between two Boys, who might act in any imaginary Parts of Business, or be allowed sometimes to give a range to their own Fancies, and communicate to each other whatever Trifles they thought fit, provided neither of them ever fail'd at the appointed time to answer his Correspondent's Letter.

I believe I may venture to affirm, that the generality of Boys would find themselves as much advantaged by this Custom (when they come to be Men), as by any other that can possibly be propos'd: But this I Submit to your Superior Judgments, and am,

Gentlemen

Dove Scripsit

Yours &c.

To a worthy Patriot

Sir. May 29th. 1740.

Zeal for the publick Good is the Characteristick of a Man of Honour, & a Gentleman; & must take place of Pleasures, Profits, and all other private Gratifications; whoever wants this Motive, is an open Enemy, or an inglorious Neuter to mankind, in proportion to the misapplied Advantages, with which Nature & Fortune have blessed him: But You have a Soul animated with nobler Views, & know that the Distinction of Wealth & Plenteous Circumstances, is a tax upon an Honest Mind, to endeavour, as much as the Occurrences of Life will give him leave, to guard ye Properties of others, and be vigilant for the Good of his fellow Subjects,

I am,

Sir, Yo.r most Obliged humb. Serv.t

The Guardian

Champion Scripsit.

A
Letter from a Servant in London,
To his Master in the Country

Sr.

As I find You are detain'd longer in the Country than You expected, I thought it my Duty to acquaint You that we are all well at Home, and to assure You, that Your Business shall be carried on with the same Care and Fidelity as if You were personally present. We all wish for Your Return, as soon as Your Affairs will permit; and, it is with pleasure, that I take this Opportunity of Subscribing my Self,

Sr. Yr. Faithful Servant,

Sam. Trusty.

Cheapside
24 June 1740.

E. AUSTIN SCRIPSIT.

TO THE

KING.

Sir,

Your Majesty commands a people capable of every thing. Not more fit to shine in arms, or maintain an extended commerce; than to succeed in the stiller pursuits of philosophy and literature. And it will be Your Majesty's glory not to let any of their talents lie unemploy'd. If Your Majesty gives the word, while some of them are busied in avenging Your cause by humbling some turbulent monarch; some in extending your dominions by new settlements, and some in increasing your peoples wealth by new trades: others will be employ'd in enlarging our knowledge by new discoveries in nature, or new contrivances of art; others in refining our language, others in improving our morals; and others in recording the glories of Your reign in immortal song.

I am, with all sincerity and devotion,

May it please Your Majesty,

Your Majesty's most dutiful,

Subject and Servant,

Britannicus.

June 30.th 1740.

Written by William Kippax in Great Ruffel Street, Bloomfbury.

N.º XLVII.

G.Bickham fculp.

A Young Gentleman's

Letter, to his Father.

Hon.^d Sir, June 27.th 1740.

This is the sixth Letter I have sent you by divers Ships, since Michaelmas last; which are I hope, all come safe to hand. I have nothing new or particular to communicate, only beg you would conceive so favourable an opinion of me, as to believe I prosecute my Studies with the utmost application; well knowing, that will prove the best recommendation to your favour at present, and most real Service to my self in time to come. All our Friends here present their kind love to you, and that you may continue in health and happiness, is the constant prayer of

S.^r Your most dutiful Son.

Edw. Dawson, scrip.

To a Gentleman of Learning, and Virtue.

SIR, July 4.^{the} 1740

The greatest Honour of Human Life is to live well with Men of Merit; and I shall always esteem it a peculiar Happiness to be reckon'd amongst the Number of y^r. Friends. The Conversation of a Gentleman, that has a refined Taste of Letters, & a disposition in which those Letters found nothing to Correct but very much to Exert, is a good Fortune too uncommon to be enjoyed in silence: In others, the greatest Business of Learning is to weed the soil; in You, it had nothing else to do, but to bring forth Fruit: Affability, Complacency, and Generosity of Heart, which are natural to You, wanted Nothing from Literature; but to refine and direct the Application of them, I am

Dear Sir,

Your Friend, and

Admirer, &c.

Written by J. **CHAMPION**, of S.^t Paul's Church-yard, **London**

TO A Young Gentleman,

Who has lately loſt a worthy Father.

Dear Sir,

The virtuous Principles you had from that excellent Man whom you have Loſt, have wrought in you as they ought, to make a Youth of Three and Twenty incapable of Comfort upon coming into Poſſeſſion of a great Fortune. I doubt not but you will honour his Memory by a modeſt Enjoyment of his Eſtate, and ſcorn to triumph over his Grave, by employing in Riot, Exceſs, and Debauchery, what he purchaſed with ſo much Induſtry, Prudence, and Wiſdom. This is the true Way to ſhew the Senſe you have of your Loſs, and to take away the Diſtreſs of others upon the Occaſion. You cannot recal your Father by your Grief, but you may revive him to his Friends by your Conduct.

Thy Father's Merit ſets thee up to View,

And plants thee in the faireſt point of Light,

To make thy Virtues, or thy Faults conſpicuous.

Dove *Script.*

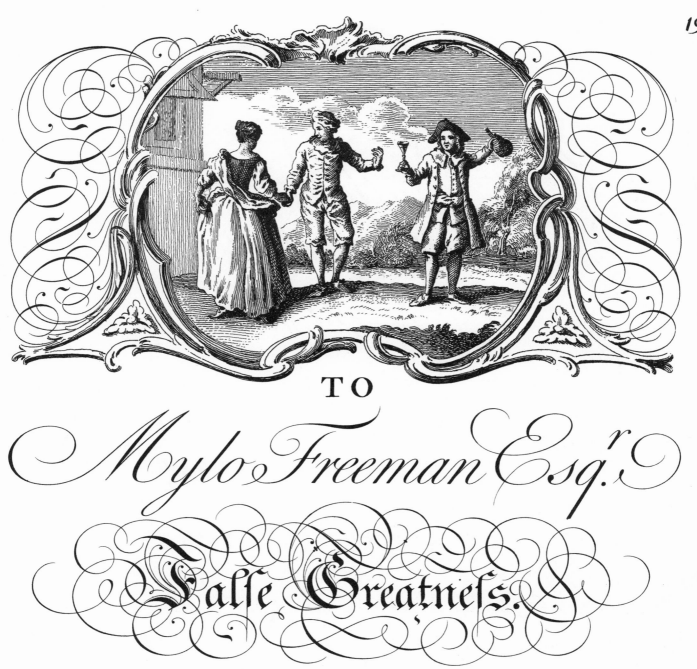

TO

Mylo Freeman Esq.ʳ

𝕱𝖆𝖑𝖘𝖊 𝕲𝖗𝖊𝖆𝖙𝖓𝖊𝖘𝖘.

Mylo, forbear to call him blest
That only boasts a Large Estate,
Should all the Treasures of the West
Meet, & conspire to make him Great.
Let a broad Stream with golden Sands
Shining thro' all his Meadows roll,
He's but a Wretch, with all his Lands,
That always wears a narrow Soul.

And mingled still with Wealth & State,
His dazzled Mind can never know;
His true Dimensions & his Weight
Are Far inferior to their Show.
Were I so tall to reach the Pole,
Or grasp the Ocean with my Span,
I must be measur'd by my Soul:
The Mind's the Standard of the Man.

𝕮𝖍𝖆𝖒𝖕𝖎𝖔𝖓 Scripsit.

Bickham Sculpsit.

To

M.^r Nathaniel Dove

Master of the Academy

In Hoxton.

Sir, Aug.st 30._{th} 1740.

The great Improvement you have made in the Art of Writing.
is a plain Proof of an uncommon Genius; and that Modesty which attends
your Merit. has justly gain'd you the Esteem of the Ablest Penmen.—
As you have been pleas'd to favour Me with several Pieces for the
Service of my Universal Penman, I think it incumbent on me to
pay you my grateful Acknowledgments for your friendly Assistance.
However, I must still desire You to write a Piece or Two more for
me in Your legible, free, and expeditious Manner, which, I doubt not, will
answer the Expectations of the most Curious: And the Sooner you Oblige
me in this Particular, the more acceptable it will be to

Sir, Your most Obliged
humble Servant

G Bickham.

Portius to Sempronius.

Well dost thou seem to check my Lingring here
On this important Hour ---- I'll strait away,
And while the Fathers of the Senate meet
In close Debate to weigh th'Events of War,
I'll animate the Soldier's drooping Courage,
With Love of Freedom, & Contempt of Life.
I'll thunder in their Ears their Country's Cause;
And try to rouse up all that's Roman in 'em.
'Tis not in Mortals to Command Success,
But we'll do more, Sempronius; we'll Deserve it.

Cato, Se. II.

Humbly Inscrib'd,

To all true Lovers of the British Constitution.

Engrav'd by Geo. Bickham, Sen.ʳ
1740.

A Kinsman to his Uncle.

Dear Uncle,

 As I did the best I could I entertained great hopes that my first performance, would have met with a kind reception at your hands; but now, having not heard from You ever since, I am afraid You did not think it worthy of an Answ.. However that be, Duty & Affection bid me not desist but send You this second Specimen of my poor Ability & Improvem.t which if you please to let me understand, You take in good part, I shall Esteem it Sufficient Encouragement to my future Progress, who am

Brompton in Kent,
June 19.th 1740.

Good Sir,

Your most Obedient,
Loving Kinsman
P. Lombard.

John Holden, Scr.

To the Worthy M.r Joseph Champion, of London, this Plate is humbly Inscrib'd,
by J.H.

THE

Ill Effects of Tyranny.

Besides Poverty and Want, there are other Reasons that debase the Minds of Men, who live under Tyranny, though I look on this as the Principal.

It is odd to consider the Connection between Despotic Government and Barbarity, & how y̍ making of one Person more than Man, makes y̍ rest less.

Too long this Queen imperiously thus Sway'd,
By no set Laws, but by her Will obey'd.
Her fearful Slaves, to full Obedience grown,
Admire her Strength, & dare not use their own.

If there be but one Body of Legislators, it is no better than a Tyranny; if there are only two, there will want a casting Voice, and one of them must at length be swallow'd up by Disputes and Contentions: Four would have the same Inconvenience as two, and a greater Number would cause too much Confusion: Therefore a mixt Government consisting of three Branches, y̍ Regal, y̍ Noble, & the Popular, is the best.

Bickham Sculpsit.

To the
Kings most Excell.t Majesty;

The humble Petition of A. B. Gent.

Sheweth,

That your Majesty has been graciously pleased to appoint your Petitioner to be Sheriff of the County of K.... wherein he would most readily, and faithfully serve your Majesty according to his bounden duty, but that his abode is very remote from the said County, and his Estate too small to support the charge of the said Office.

Your Petitioner therefore most humbly prays your Majesty will be graciously pleased to appoint some more fit & able person to the said Office

And your Petitioner (as in duty bound) shall ever Pray, &c.

Design'd, & Written by J. Champion, in the Year 1740.

G. Bickham Sculpsit.

To the Right Honourable the Lords Commissioners of the Admiralty.

The humble Petition of George Froy.

Sheweth,

That Your Petitioner hath served in his Majesty's Royal Navy seven Years in quality of Able Seaman, and five Years as Gunners Mate on Board his Majesty's Ships the Cumberland and Dartmouth Capt. Brown Commander,

That He passed Examination for a Gunner November 12. 1739. & humbly refers Your Lordships to the Certificates hereunto annexed.

Your Petitioner humbly Prays Your Lordships to Appoint him Gunner of the Britannia Sloop, Sr. John Saunderson Commander.

And as in duty bound shall ever Pray, &c.

Dove, scr.

These are to Certifie whom it may Concern that the bearer hereof George Froy Served five Years in Quality of Gunners Mate on Board his Majesty's Ships the Cumberland & Dartmouth both under my Command, during which time he behaved Soberly Diligently and Obedient to Command, And I recommend him as deserving Encouragement. Given under my hand on Board his Majesty's Ship the Cumberland this 12 day of October, 1739.

Brown

To the Right Honourable the Lords Commissioners of the Admiralty.

We whose Names are hereunder Written Gunners, in his Majesty's Royal Navy, do hereby Certifie that George Froy Performed the Several Heads of Examination appointed by Your Lordships to Qualify him for a Gunner on the 12 of November, 1739. And we do believe him capable to Serve as Gunner on Board any of his Majesty's fourth Rate Ships. Given under our hands on Board the Namure this 14 day of November, 1739.

J. Longman		Namure
W. Salter	Gunner	Cornwall
J. Thomas	of the	Grafton
Geo. Hind		Cumberland

Dove, scr.

Freedom.

Sweet are the Jess'min's breathing Flow'rs,
Sweet the soft falling Vernal Show'rs;
Sweet is the Gloom the Grove affords,
And Sweet the Notes of Warbling Birds;
But not the Groves, nor Rains, nor Flow'rs,
Nor all the Feather'd Songsters Pow'rs,
Can ever Sweet, or Pleasing be,
O, lovely Freedom! without Thee.

Emanuel Austin Scripsit 1740.

Nᵒ L. _____ G.B. sculp

To the Right Honourable the

Lord-Mayor, and Court of Aldermen,

Of the City of London.

A B C D E F G H I.

To the Hon.ble the Sub-Governor,

Deputy-Governor, and Directors of

the South-Sea Company.

J K L M N O P Q R

To the Honourable the

Governor, Deputy-Governor, and Directors

Of the Bank of England.

S T V U W X Y Z &.

Invented, & Written by Joseph Champion

Master of the Boarding-School, in

King's-Head-Court, St. Paul's Church-Yard.

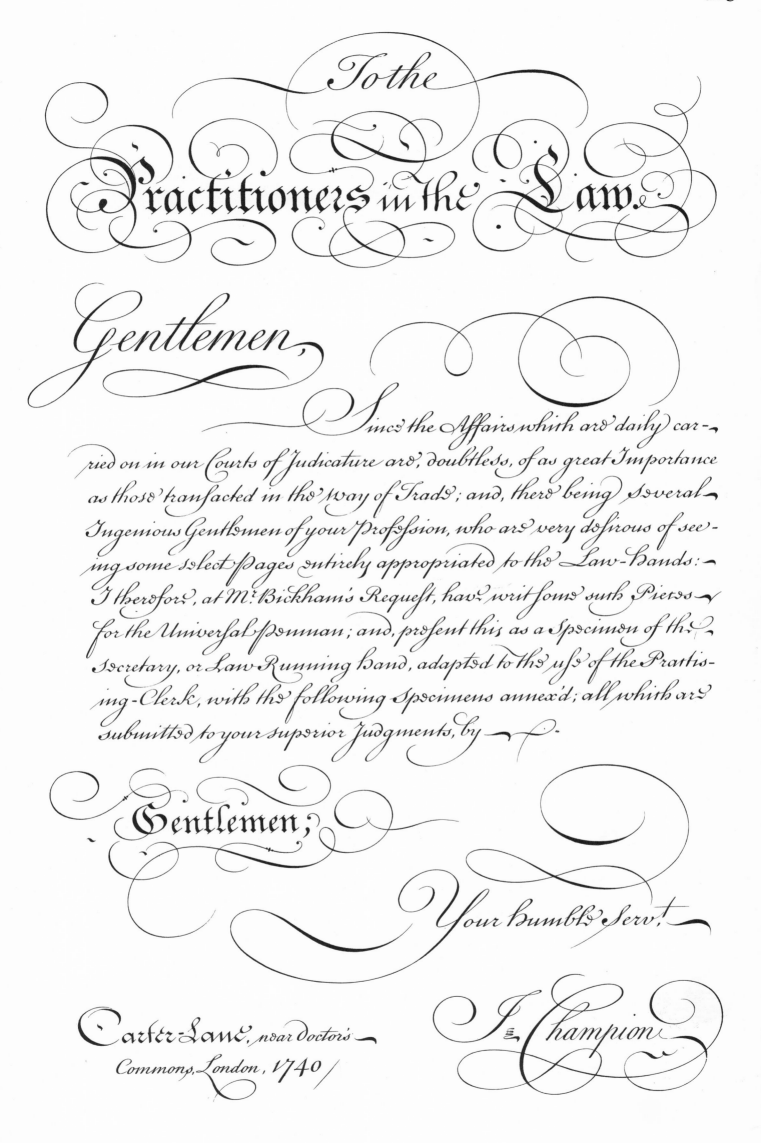

To the

Practitioners in the Law.

Gentlemen,

Since the Affairs which are daily carried on in our Courts of Judicature are, doubtless, of as great Importance as those transacted in the Way of Trade; and, there being several Ingenious Gentlemen of your Profession, who are very desirous of seeing some select Pages entirely appropriated to the Law-Hands: I therefore, at Mr. Bickham's Request, have writ some such Pieces for the Universal Penman; and, present this as a Specimen of the Secretary, or Law Running Hand, adapted to the use of the Pratising-Clerk, with the following Specimens annex'd; all which are submitted to your superior Judgments, by

Gentlemen,

Your humble Servt,

Carter-Lane, near doctors Commons, London, 1740

J. Champion

A Man who entertains an high Opinion of himself is naturally ungrateful: He has too great an Esteem of his own Merit to be thankful for any Favours received. *amm*

Tho' Square-Text once Triumphantly did Stand,
And boldly ushe'd in th' Engrossing-Hand;
Tho' wanting Merit now, did Shine of Old,
In This Indenture, and to Have and Hold.

Mere Bashfulness, without Merit, is Awkward; and Merit, without Modesty, insolent: But Modest Merit has a double Claim to Acceptance, and generally meets with as many Patrons as Beholders. *ama*

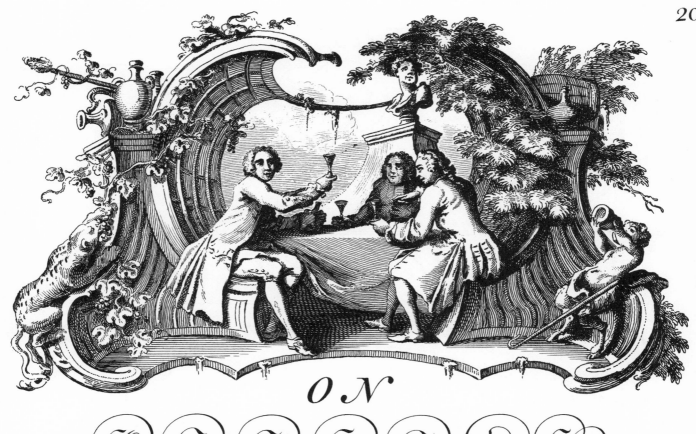

ON LIBERTY;

Written in 1707,

By the late DUKE of Devonshire.

O despicable State of all that groan
Under a blind Dependency on One!
How far inferior to the Herds that range,
With Native Freedom o'er the Woods & Plains!
With them no Fallacies of Schools prevail,
Nor of a Right Divine the nauseous Tale,
Can give to one among themselves the Pow'r,
Without Controul his Fellows to devour.
To reasoning Human Kind alone belong,
The Arts to hurt themselves by reas'ning wrong.

How'ere the foolish Notion first began,
Of trusting Absolute to lawless Man;
How'ere a Tyrant may by Force subsist;
For who would be a Slave that can resist?
Those set the Casuist safest on the Throne,
Who make the People's Interest their own.
And chusing rather to be lov'd than fear'd,
Are Kings of Men, not of a servile Herd.
O Liberty, too late desir'd, when lost,
Like health, when wanted, thou art valu'd most!

Bickham, scrip.

THE
Oriental Languages.

INTRODUCTION.

The Hebrew is the most antient Language in the World, at least that is known to the Europeans: The square Hebrew Character is originally the Chaldee Character, which the Jews assumed during the Babylonish Captivity. As particular Companies of Men became Inhabitants of different parts of the World, and had different Languages, so they invented various Characters: The Greeks and Romans have herein been most famous, and their Characters are chiefly us'd in Europe; but the Oriental Nations have their own peculiar manner of Writing, several Specimens of which, may be seen in the following Page.

Emanuel Austin Scripsit.

George Bickham Sculpsit.
1741.

VARIOUS
Texts of Scripture, with Alphabets.

HEBREW.

אֲבָרֲכָה אֶת־יְהוָֹה בְּכָל עֵת תָּמִיד
תְּהִלָּתוֹ בְּפִי : בַּיהוָה תִּתְהַלֵּל נַפְשִׁי
יִשְׁמְעוּ עֲנָוִים וְיִשְׂמָחוּ : גַּדְּלוּ לַיהוָה אִתִּי
וּנְרוֹמְמָה שְׁמוֹ יַחְדָּו :

א. ב. ג. ד. ה. ו. ז. ח. ט. י. כ.
ל. מ. נ. ס. ע. פ. צ. ק. ר. ש. ת.

SAMARITAN.

[Samaritan script text]

[Samaritan alphabet]

ARABICK.

ٱلسَّلَامُ لَكِ يَامَرْيَمُ ٱلْمُمْتَلِيَةَ مِنَ ٱلْنِّعْمَةِ ٱلرَّبُّ
مَعَكِ مُبَارَكَةٌ أَنْتِ فِي ٱلنِّسَاءِ وَمُبَارَكَةٌ
ثَمَرَ بَطْنِكِ يَسُوعُ *

ا ، ب ، ت ، ث ، ج ، ح ، خ ، د ، ذ ، ر ، ز ، س
ش ، ص ، ض ، ط ، ظ ، ع ، غ ، ف ، ق ، ك
ل ، م ، ن ، ه ، و ، لا ، ي

RABINICAL.

[Rabbinical Hebrew script text]

[Rabbinical alphabet]

SYRIACK.

[Syriac script text]

[Syriac alphabet]

ARMENIAN.

Հայր մեր որ յերկինս ես սուրբ
եղիցի անուն քո. եկեսցէ արքայու-
թիւն քո. եղիցին կամք քո որպէս
յերկինս եւ յերկրի.

ա. բ. գ. դ. ե. զ. է. ը. թ. ժ. ի. լ. խ. ծ.
կ. հ. ձ. ղ. ճ. մ. յ. ն. շ. ո. չ. պ. ջ. ռ.
ս. վ. տ. ր. ց. ւ. փ. ք. եւ.

Bickham Sculpsit.

GREEK.

ΙΣΗ πιϛεύᾳν τὸν κόσμον ἐῆ Φθαρτὸν, ὁπῆ κὰ γέγονε
ιμτ δὲ τω Φθοραὰν, εἰς ἀφθαρσίαν πάλιν μεϛαποι:
ούμλιον. σὐδὲν γῂ τῆν πρὰ Θεοῦ γεγονότων εἰς ὃ
μὴ ὂν χωρήσᾳ, κἂν ὃ τῆς ἁμϸτίας πραϖλωμα, ἅμα
ἡμῖν, καὶ πᾶσᾳν τω κλίσιν τῇ Δαλύσᾳ συγκατεδίκασεν.

α α · β ϭ · γ γ ͠ · Δ δ ᴅ · Ε Ϭ ε · ζ ζ · ιι η н · ϑ ϑ θ φ · ι ι · Κ κ λ
μ · ν · ξ · ο ο · ϖ π · ρ ρ ς · Ϲ Ϲ ς σ · Τ ͵ τ · υ υ · φ φ φ χ · ψ ω

A · B · Γ · Δ · E · Z · H · Θ · I · K · Λ · M · N · Ξ · O ·
Π · P · Σ · T · Y · Φ · X · Υ · Ψ · Ω · ϖ ·

Τῷ δὲ αὖ πονοιῶτι χ ϑεὸς συλλαμϭάνει

G. Bickham Sculpsit.

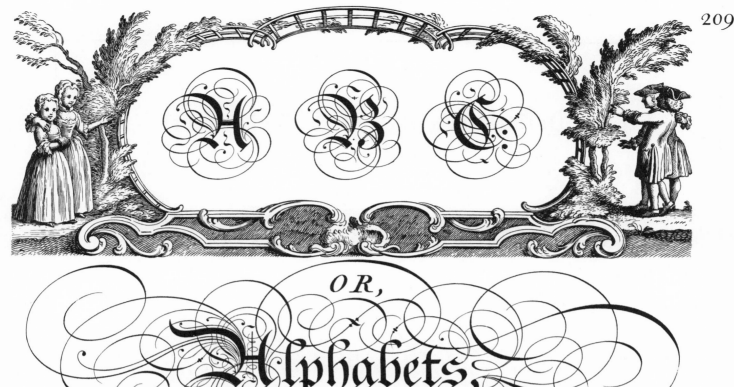

OR,

Alphabets,

In all the usual Hands now Practis'd, &c.

Engrav'd by G. Bickham, Sen.r

The Alphabet is the whole Order of the Letters in any Language, from Alpha and Beta, the two first Letters in the Greek Tongue. The English Alphabet contains twenty Six Letters, but others differ in their Number and Form, and vary in their Placing and Writing. The Hebrews write from the Right hand to the Left, Others from Left to Right, and back again from Right to Left: The Chinese from Top to Bottom, and from Right to Left; but the Europeans, and most Others, write from Left to Right, without Retrogression to the Left. All our English Alphabets are exhibited in the two next Pages.

If you would write both Legible and Fair,
Copy these Alphabets with all your Care.

N.o LII. *G. Bickham Fecit.* MLCCXLI.

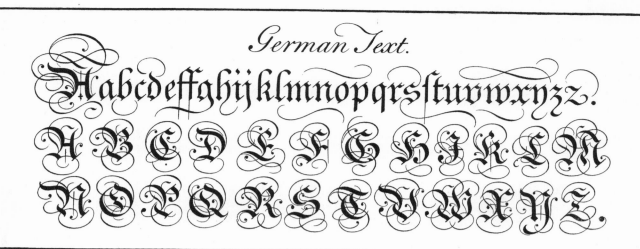

German Text.

Aabcdeffghïjklmnopqrsstuvwxyzz.

ABCDEFGHIKLM
NOPQRSTVWXYZ.

Round Text.

Aabbcdefffghhhiijkkkllmn
oppqqrzsftttuvvnxyyyz

Square Text.

ABCDEFGHIFKLM,
abcdefffghïjklmnopqrsftuvwxyz
NOPQRSTVWXYZ

Round Hand.

abbcddefoghhhiijkkkllmnnoppqrsfstuvvnxyz.
ABCDEFGHIJKLMMM
NNOPQRSTUVWXXYYZ.

Engrossing.

Aa. Bb. Ct. Dd. Ee. Ff. Gg. Hh. Ii. Jj. Kk. Ll. Mm. Nn. Oo.
Pp. Qq. Rr. Ss. Tt. Uu. Vv. Ww. Xx. Yy. Zz.

Secretary.

Aambntudmeasfugnhimijnkulunnompraqurshsntmuvwxmyzz.
ABCDEFGHIFKLMNOPQRSTVWXYZ.

Joseph Champion scr.

Old English Print.

Aabcdefghijklmnopqzrfsßtuvwxyz.&c.

ABCDEFGHJKLMNOP
QRSTUWXYZZJC

Italick Print.

Aabcdefghijklmnopqrfstuvwwxyz.æœ

ABCDEFGHIJKLMNOPQR
RSTUVWXYYZÆ.

Roman Print.

Aabcdefghijklmnopqrfstuvwxyz.

ABCDEFGHIJKLMNOPQ
RSTUVWXYZ.

Italian Hand.

aabbccddeefffoghbijkkllmmnoppqrsfsttuvwxyzz.

ABCDEFGHIJKLMMN
NOPQRSTUVWWXYZZ.

Court Hand.

The Chancery.

AaBCcDdEeFfffGghhJiijKkLllMmNn
OoPpQqRrzSfsStVuvWwXxYyZzut. Champion Scrip.

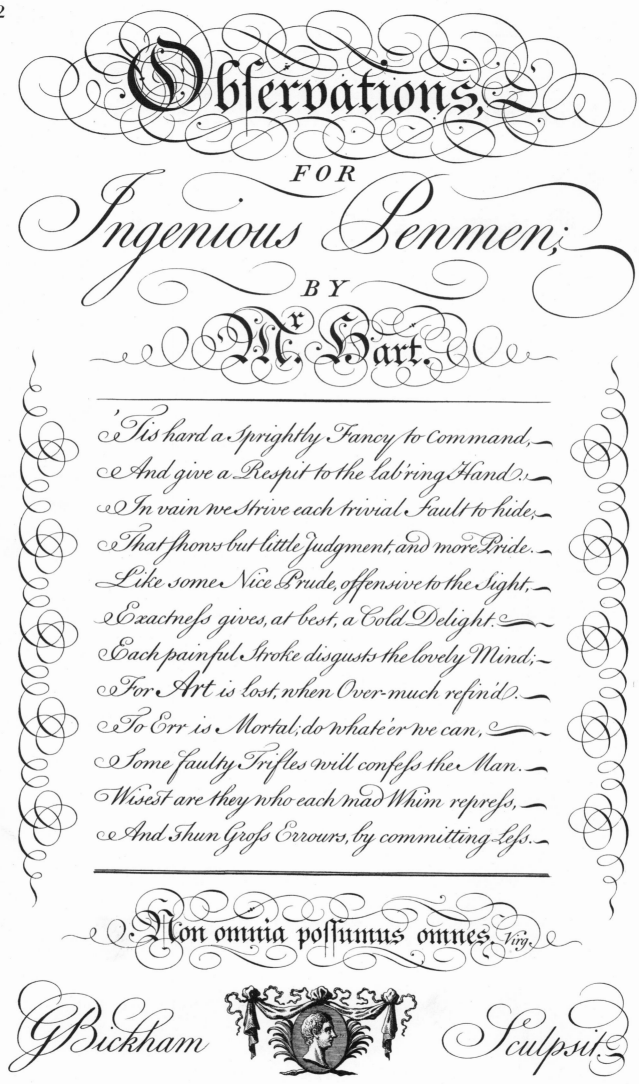

Observations,

FOR

Ingenious Penmen;

BY

Mr Hart.

'Tis hard a sprightly Fancy to command,
And give a Respit to the lab'ring Hand.
In vain we strive each trivial Fault to hide,
That shows but little Judgment, and more Pride.
Like some Nice Prude, offensive to the Sight,
Exactness gives, at best, a Cold Delight.
Each painful Stroke disgusts the lovely Mind;
For Art is lost, when Over-much refin'd.
To Err is Mortal; do whate'er we can,
Some faulty Trifles will confess the Man.
Wisest are they who each mad Whim repress,
And Shun Gross Errours, by committing Less.

Non omnia possumus omnes. Virg.

G. Bickham Sculpsit.

FINIS.